Artists'

Questions Answered Drawing

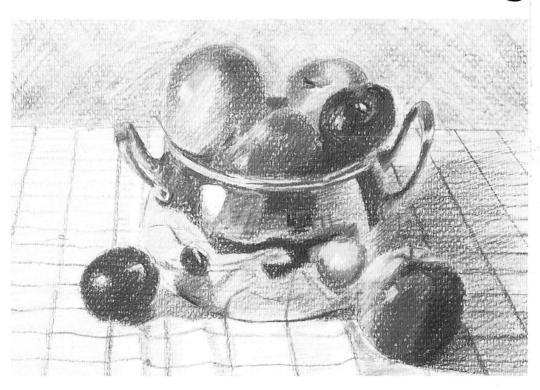

JEREMY GALTON

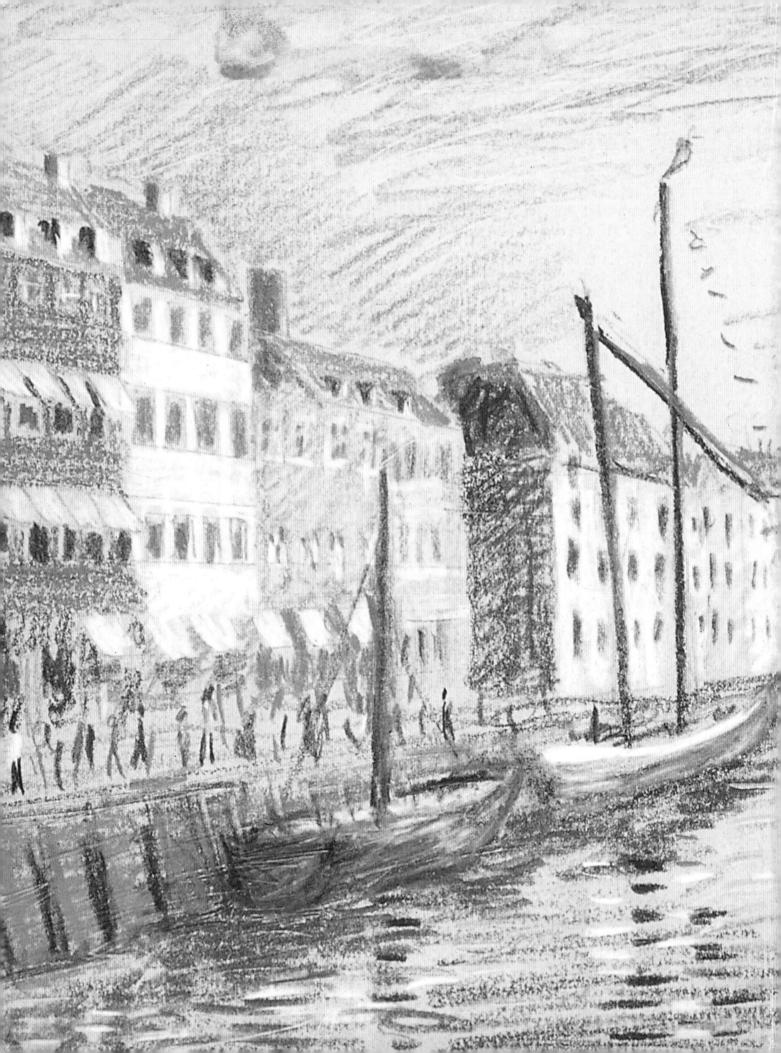

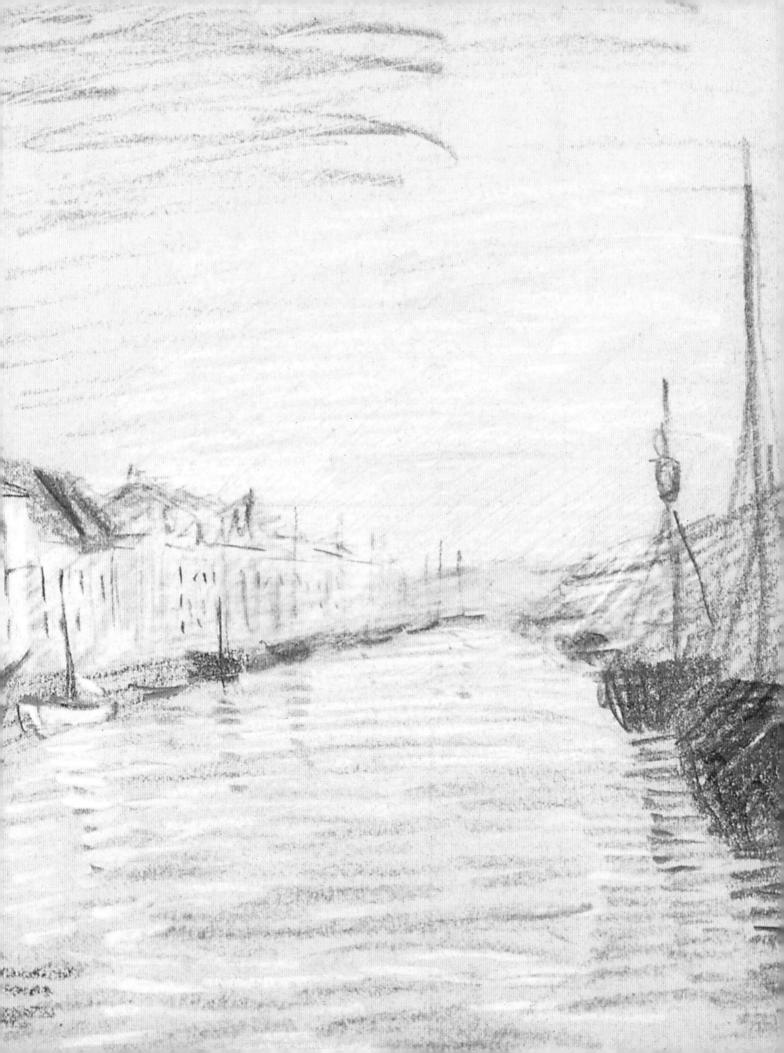

A QUINTET BOOK

Published by A&C Black Publishers 37 Soho Square London W1D 3QZ www.acblack.com

Copyright © 2004 Quintet Publishing Limited. All rights reserved. No part of this publication may be reproduced, stored in a retrieval system or transmitted in any form or by any means, electronic, mechanical, photocopying, recording or otherwise, without the permission of the copyright holder.

ISBN 0-7136-6927-6

This book was designed and produced by Quintet Publishing Limited 6 Blundell Street London N7 9BH

AQAC

Senior Project Editor: Corinne Masciocchi Editor: Anna Bennett, Duncan Proudfoot

Designer: James Lawrence Photographer: Paul Forrester Creative Director: Richard Dewing

Publisher: Oliver Salzmann

Manufactured in Singapore by Universal Graphics Pte Ltd. Printed in China by Midas Printing International Limited

Contents

Introduction		6
Key terms		8
Chapter 1	Basic drawing techniques	10
Chapter 2	Portraying still life	40
Chapter 3	Rendering outdoor scenes	64
Chapter 4	Drawing interiors	96
Chapter 5	Drawing people and animals	114
Index		143

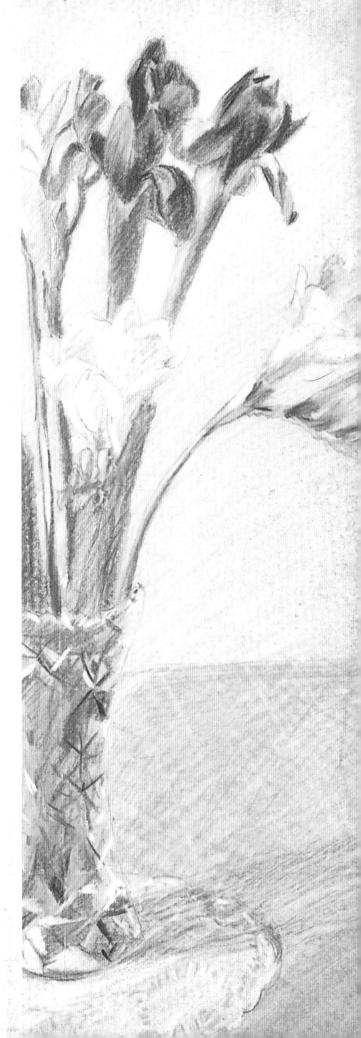

Introduction

A possible definition of drawing is the art of representing the three-dimensional world on a flat plane, using only single lines. The distinction between drawing and painting is obscure; you can draw with paint, and you can build up complex pictures using colored pencils in the style of painting. This book covers pictures constructed using implements that only leave a single line on paper (whereas painting leaves wide or narrow swathes of paint). Ordinary pencils, colored pencils, graphite, and pen and ink are the main tools discussed, but you can also draw with chalk, conté crayons, felt tip pens, and ballpoint pens.

It is only relatively recently that drawings have been done for their own sake. Up until the eighteenth century, artists regarded drawing as a means to producing paintings. Studies of

anatomy, such as those by the great Renaissance painters, were all preparatory drawings and were certainly not meant to framed and hung as they are today in museums and galleries.

Drawing is a very convenient way to produce images, requiring none of the cumbersome equipment needed for painting. A pencil and sketchbook are an ideal way to record a vacation. Landscapes, townscapes, flowers, and people all make ideal subjects for drawing.

A drawing or sketch carries with it all your observations and emotions felt at the time and is a much better reminder than a photograph. Every line in the drawing represents something you have actually seen, whereas you hardly need to look at your subject when taking a photograph. While a photograph tells you what was actually there, a drawing is a record of what you saw. Many artists carry a sketchbook with them at all times and constantly draw wherever they are. They become very skilled at seeing things instantly and can draw very quickly, hardly having to think about all the techniques described in the following pages. You too can improve rapidly—a little guidance followed by lots of practice makes perfect.

Use the best-quality paper and drawing implements to be found in your local art shop. Avoid cheap paper, which turns yellow fairly quickly, and poor-quality colored pencils, which fade because the pigments and dyes used are not designed for permanency.

The bewildering array of pencils that is available can be confusing. A pencil "lead" is made of graphite (a form of carbon) ground

with varying amounts of clay. The greater the proportion of graphite, the softer the lead and the darker the line it produces. Pencils are graded, from the hardest to the softest, as follows: 8H, 7H, 6H, 5H, 4H, 3H, 2H, H, HB, F, B, 2B, 3B, 4B, 5B, 6B, 7B, 8B. The hardest pencils leave a pale gray or silvery line, and the softest pencils leave a dark black line. To begin with, try a selection of pencils ranging from 3H through HB to 6B.

Charcoal or charcoal pencils are soft and leave a very dark line; they can cover large surfaces quickly. If you draw on a toned paper, you can add white highlights to your drawings using various chalks or Chinese (or China) white.

Drawing with pen and ink is an excellent method to try after you have gained some confidence with pencil. Unlike pencil, a pen is an all-or-nothing tool—it either leaves a deposit of ink or it doesn't. Ink can't easily be erased either, so you have to be confident in what you are doing.

You will probably want to introduce color to your drawings, either straight away or after you've had some practice with ordinary pencils. Colored pencils are made from mixtures of kaolin, waxes, and dyes and vary considerably in width, softness, and range of color. Boxed sets are readily available, but you can also buy individual colors to replace frequently used colors or to add to your range, or to try out pencils made by other manufacturers.

There are many different types of art papers available that vary in size, thickness, and texture. The texture of a paper refers to its

roughness or "tooth," and this depends on the size and lie of the fibers. Rougher papers—those with more tooth—have more "bite" and take more pigment from a pencil. They show a better line with harder pencils, while softer pencils leave a good line on fine-toothed papers. Try out many different combinations of pencils and papers to see which ones suit your style best. Paper can be bought in pads or as individual sheets, and a sketchbook is very useful to carry around. If using individual sheets, it is best to fix these to a wooden drawing board with masking tape or clips.

Erasers are essential—many artists remove marks just as frequently as they make them—and an ordinary plastic eraser is very useful with many kinds of pencil. Kneaded erasers are also useful as they remove pencil lines just by pressing on them. Spray finished drawings with fixative to prevent smudging—an aerosol is convenient, or you can use a diffuser.

Key terms

Aerial (or atmospheric)
perspective—The gradation of
color and tone as features in a
landscape recede from the
viewer. Color becomes bluer and
tone paler with distance.

Background—The space behind the main subject in a composition.

Blending—The gradual merging of one color into another.

Blocking in—The laying in of the main areas of color and tone during the early stages of a drawing or painting, to be refined at a later stage.

Burnishing—Rubbing over a color with white pencil or Chinese white to enhance and lighten the underlying color and to produce a smoother texture. (This also applies to rubbing with an eraser or with a paper stump to create a sheen on the lower layer.)

Charcoal—Formed by the carefully controlled partial combustion of wood. Consists of a purer and less compact form of graphite than in a pencil.

Chinese white—A chalky pencil containing zinc oxide pigment.

Color density—A color's strength or brilliance once applied to paper.

Colored ground—Colored paper, or white paper tinted with a layer of ink or paint.

Complementary colors—Colors that lie opposite each other on the color wheel and have the effect of enhancing their opposite.

Composition—The spatial arrangement on the picture plane of areas of tone, color, and features of interest.

Conté crayon—A type of synthetic chalk named after its French inventor, Nicolas Jacques Conté (1755–1805), often in pencil form encased in wood. Available in black, white, red, and brown.

Contour—Edge or outline of a form, which can be drawn with a single line.

Crosshatching—The criss-crossing of lines to create tone, mainly used to darken areas of shadow.

Ellipse—A circle seen in perspective. It appears as an ovoid disk.

Felt tip pen—An inexpensive, disposable marker available in a wide range of colors; not necessarily lightfast.

Fixing—The spraying of a thin layer of varnish (or fixative) onto a drawing to prevent it from smudging.

Focal point—The main center of interest in a drawing.

Foreground—The part of a picture that is nearest to the artist or viewer.

Foreshortening—The apparent shortening of a form when viewed from an end-on position.

Form—The three-dimensional structure and shape of an object.

Graphite—A form of carbon. Pencil "lead" is a mixture of finely ground graphite and clay.

Hatching—Technique of drawing parallel lines close to each other to create shading.

Highlight —A region that reflects more light than its immediate surroundings. Particularly bright, small highlights often occur on convex surfaces.

Hue—A color of the spectrum (from red through violet).

Image—Describes the drawing or part of the drawing. Can also be used to describe the subject being drawn.

Intensity—The strength or brilliance of color or tone.

Linear perspective—The representation of space utilizing the fact that objects appear to diminish in size as they recede from the viewer and that receding parallel lines appear to meet at a point in the distance, usually on the horizon.

Local color—The actual color of an object regardless of its illumination or distance

Modeling—The illusion of three-dimensional form in a drawing or painting by gradation in tone and/or color.

Monochrome—The use of a single color only in a picture (black or white may be used in addition.)

Negative shapes—The shapes between or around the main objects in a picture.

Ochres –Natural brown or yellowish earths used as pigments.

Optical mixing—The blending by eye of numerous small areas of two colors that lie in close proximity to each other. The result is the illusion of a third color. For example, alternating dots of blue and yellow will appear green.

Perspective—See Linear perspective and Aerial perspective.

Picture plane—The defined surface area being painted.

Pigment—A finely ground natural or synthetic substance that gives color to a colored pencil, pastel, or paint.

Plumb line—An imaginary or drawn line linking features vertically as an aid to drawing.

Rule of thirds—The widely accepted idea that the division of the main areas of a picture into approximate thirds can give a particularly satisfying composition.

Scale—The size of objects in relation to each other and to the confines of the picture.

Shading—The darkening of an area of a drawing by toning, cross hatching, etc.

Sight size—A drawing which, when held at arm's length, appears the same size as its subject.

Stippling—The creation of tone by the drawing of small dots; mainly confined to inks.

Technical pen—A pen with a fine tubular metal nib that gives fine lines of constant thickness.

Texture—The term used when the artist conveys the "feel" of the subject, not just its form and color, such as a furry leaf or a velvety petal.

Tint—A color either diluted or mixed with white.

Tonal value—The darkness of tone in relation to the other tones of a drawing.

Tone—The darkness or lightness of a color irrespective of its hue.

Toning—The creation of tone by fine shading so that the pencil strokes are not obvious.

Tooth—The texture of the paper surface that allows pigment to "bite" and settle with varying density.

Underdrawing—The initial drawing and colors laid down prior to the final layers of color; applies to colored drawings (and paintings) only.

Undershading—The application of dark tones prior to the addition of subsequent colors. The undershading shows through, hence darkening the final effect.

Vanishing point—The point, usually on the horizon, where receding parallel lines appear to meet.

1 Basic drawing techniques

The mental processes involved in drawing are necessarily complex, but there are many "tricks of the trade" that can make drawing considerably easier, and a number of these form the bulk of this chapter. Whatever you are drawing—be it a still life, a landscape, or a figure—you will be confronted by a collection of shapes. Somehow these have to be translated onto paper—a daunting prospect if you have never tried before. The task is to observe the objects in front of you.

For the inexperienced, perhaps the main stumbling block encountered when drawing is the assessment of apparent lengths and distances in the subject before them. Seeing lengths and proportions is not always easy, and the eye can trick you into thinking that apparent lengths are longer or shorter than they really are. Preconceived ideas can mislead you. Most people do not realize, for example, just how long the legs are compared to the rest of the body; when they attempt their first drawing, they almost invariably draw the legs too short.

One of the basic techniques for avoiding this particular problem is to learn how to measure proportions and the apparent lengths in front of you. By holding a pencil or ruler up to your subject at arm's length, you can compare which distances are the same.

For example, you may find that the distance between the elbows of your sitter is identical to the height of the chair leg—easy by this method but much more difficult to see by eye alone. A refinement of this technique is actually to measure apparent distances on a ruler held at arm's length and use these very measurements on your drawing (see What is meant by drawing "sight size"?, page 24).

In this chapter there are answers to questions on drawing ellipses, applying perspective, and estimating distances between receding features such as columns, fence posts, or the tiles on a floor. It is extraordinary to think that the early painters had no idea of perspective. Their drawings and paintings do indeed look "wrong" to our eyes but are very beautiful and of great interest nonetheless. Ellipses are forever cropping up, particularly in still life, and are never easy to draw, but you will find the hints given in this chapter helpful.

Questions on the practical aspects of drawing are also answered in this chapter, and they range from how to hold a pencil to how to blend colored pencils to create new colors.

Many of these techniques are personal to the individual, and the suggestions here should merely help you proceed, if you have not yet had the chance to develop ideas of your own.

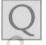

How should I hold a pencil?

Having good control over your drawing implement is what matters most, and the way you hold it is, to some extent, personal preference. However, there are a number of generally accepted ways, with a selection illustrated below. You should feel comfortable with a pencil so that you don't have to think about it while drawing. Adopt a hold that suits your style and gives you maximum control.

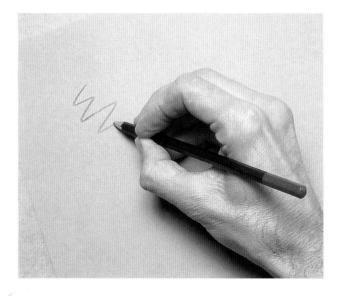

This is the standard way to hold a pencil: the way in which most people would write. It allows for greatest control since most of the movement can be directed by the fingers. In the same position and with the fingers kept still, the whole hand can sweep back and forth by bending at the wrist.

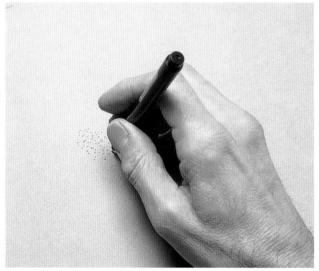

Use a technical pen to stipple fine dots over the paper surface. Ink is immediately deposited on contact with the paper, so the faster you deliver your strokes, the more dots are accomplished. Rest your wrist on the paper, and sweep your hand across the page using a rapid "sewing machine" action. This gives finer control than if the hand were suspended above the paper.

The wrist in this position is less flexed than in the standard hold, and you will discover that your hand will tire less quickly. Use this hold when you are drawing on a vertical surface at an easel.

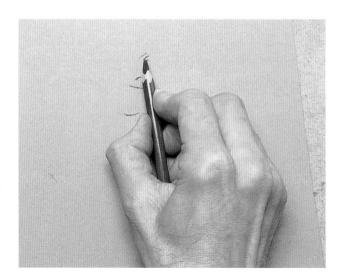

How do I draw form realistically?

Form refers to the three-dimensional shape of an object. When illuminated perfectly uniformly, it is often impossible to tell whether a shape is a three-dimensional form or a flat plane, although a slight rotation may give it away. With side lighting, the object receives graded illumination; as the various surfaces bend away from the light source, they get darker. Shade these shadow areas to give a drawing a three-dimensional form. To show it in the context of its surroundings, draw the shadow cast on the ground by the object as well.

Without any shading, the form of the cylinder on the left is ambiguous, while the drawing on the right has linear clues as to its cylindrical form. Similarly, a cone viewed from the side would appear as a triangle (unless it were tilted and its base visible), whereas an unshaded sphere could only appear as a circle.

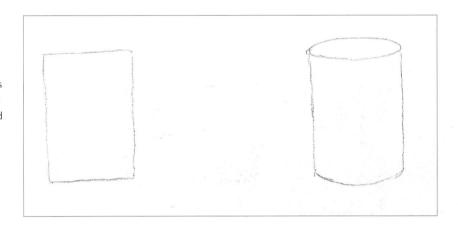

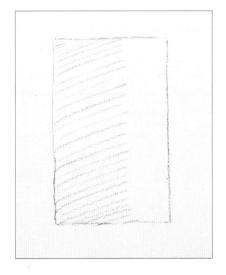

Apply hatch marks to about two thirds of the cylindrical area to give it a more circular shape. You will discover that more detail is necessary to make it appear rounded. It could be interpreted as such, assuming illumination from the right leaves the left side in shadow.

Add another layer of hatching at a different angle (crosshatch) to make the left side darker still. This will further emphasize its curvature. This additional shading also shows the degree of shadow increasing as its wall curves away from the light.

Add another layer of shading to establish the three-dimensional form of the cylinder. Add increasing amounts of shadow by hatching, each time at a different angle.

The extreme left edge of the cylinder is pale. This paling at the edge of the shaded side of a three-dimensional form often occurs from back lighting from a distant wall or the far paler surface on which the object rests.

Any three-dimensional object lit from the side will cast a shadow on the ground and perhaps on other objects too. Lightly sketch in the shadow cast by this cylinder to indicate its relationship with the ground on which it is resting.

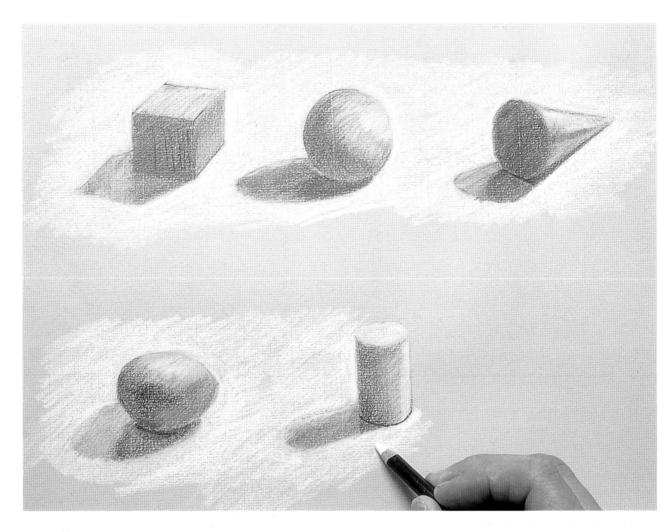

Draw these forms on tinted paper with a 5B pencil and burnish them with Chinese white. Draw the background and some highlights with Chinese white, too. Decide where to put the shadows by looking carefully at the original objects.

BOWL AND MUG

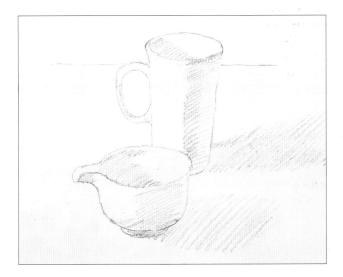

Describe the bowl and mug by contour only. While a line drawing can be valid in its own right, it tells us nothing about the texture of the objects and little about their form.

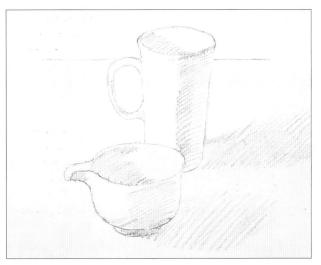

Shade the darkest regions by simple hatching. Even with such crude treatment, form is now beginning to emerge. Illumination is evidently from the left, and the shadows cast on the ground help to establish the spatial relationships between the objects, giving much more depth to the picture.

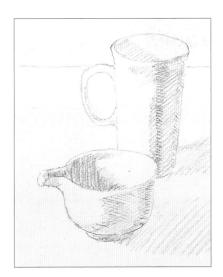

Crosshatch the shaded areas in the darkest regions of the actual objects. Remember to look at the objects in front of you and draw what is there. It is sometimes easier to see the tonal relationships by squinting your eyes—you will then not be distracted by detail, and will only be able to see the main blocks of shadow.

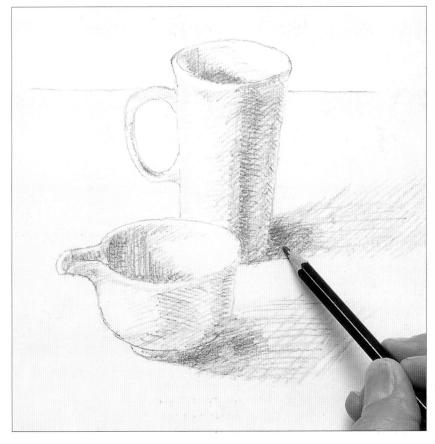

Form is fully apparent now and no ambiguity remains. Add detail, such as the thin shadow below the rim of the bowl. The darkest part of the outer wall of the mug almost faces the viewer. To its right is a pale zone receiving illumination from elsewhere.

What effects can I achieve using colored pencils?

Colored pencils are a convenient way to include color in your pictures, as paints—especially oils and acrylic—require cumbersome equipment and can be messy. Colored pencils are versatile and can produce a wide range of effects on any type of paper. The greater the pressure you exert on the pencil, the more pigment is deposited, and the greater the color density of the mark made. Layer upon layer of different colors will create new colors by the process of "optical mixing."

OVERLAYING COLOR

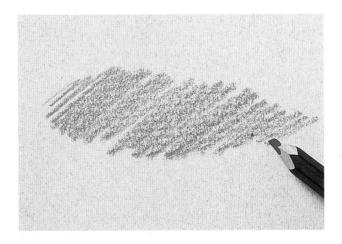

Zigzag a blue pencil with medium pressure over the paper to produce a patch of color. The gray paper below still shows through. By exerting greater pressure, you can force more of the blue pigment into the teeth of the paper, producing a darker, richer color.

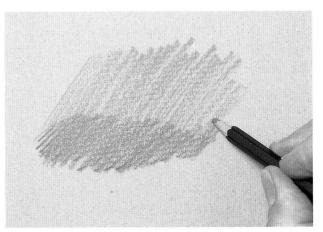

Overlay the same blue patch with scarlet. This reduces the intensity of the blue, and, although the new color cannot exactly be described as purple, it tends toward it. A red, such as crimson, that contains a greater element of blue would create a more purple hue.

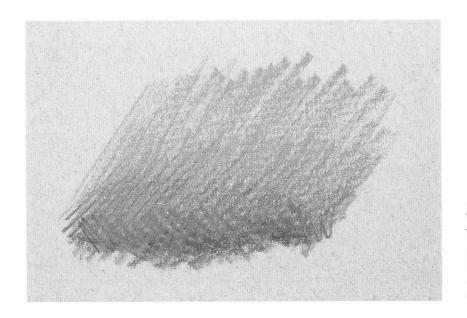

Add yet more blue to the same patch by crosshatching over the lower part. The use of blue in this way creates shadow for red coloring. You can also use brown or purple to darken red. Some quick experiments using different colors will show you the effects of color mixing.

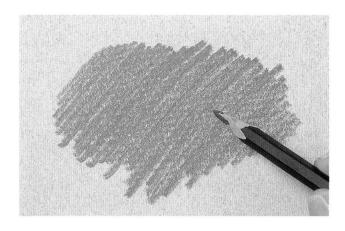

Draw a fairly uniform patch of purple, leaving virtually no gaps between the pencil strokes. The only gray paper to show through is where the deep teeth have received no pigment.

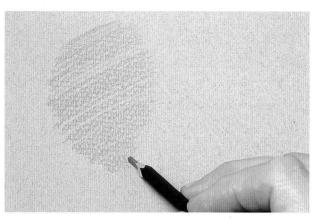

Lightly apply a layer of green to the paper. Gray paper should still show through so that the color density of the green is very low.

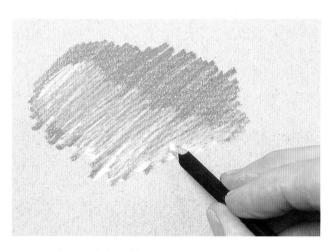

Press Chinese white over the purple to show the effect of burnishing. The purple becomes paler in tone and the richness of its color is considerably enhanced. Chinese white, being softer in texture, fills the teeth of the paper.

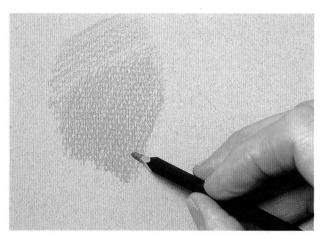

Crosshatch the lower part of the green with the same green to produce a deeper tone. For this second layer of color, push the pencil a little harder, so that the new strokes are darker.

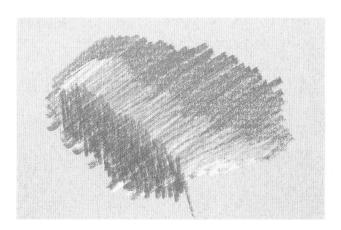

Hatch more purple over the white to intensify the color.

The white pigment below glows through it, giving a rich, bright purple. No gray paper shows through the color any more.

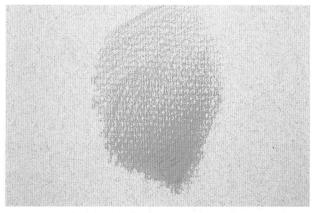

Apply a third layer of crosshatching with even more pressure to give an even deeper tone. You can achieve a considerable tonal range using a single pencil.

COLOUR COMBINATIONS

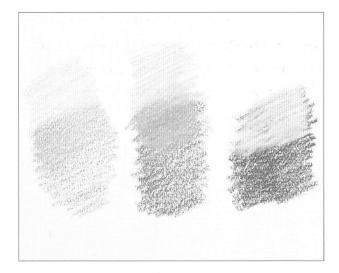

Overlay the lower patches of color with yellow or Chinese white. Where yellow overlaps the blue (left), a green is created. This is an excellent way to make a rich green consisting largely of tiny blue and yellow flecks of pigment. Yellow over red makes orange (center), and white over crimson creates pink (right).

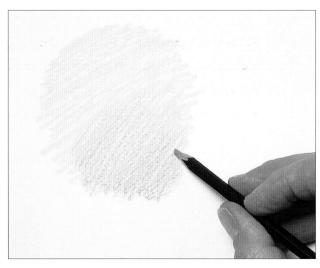

Brown is essentially dark yellow, while ochre falls between yellow and brown. Add brown or ochre to yellow to darken its tone without greatly changing its hue. Experiment with as many color combinations as possible. Also try reversing the order of application of each color.

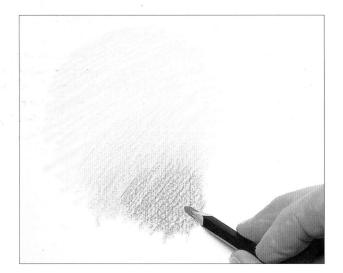

Add some hatching of purple to the lower part of the previous color swatch. Apply red over the purple, giving an overall brown color and so effectively darkening the yellow.

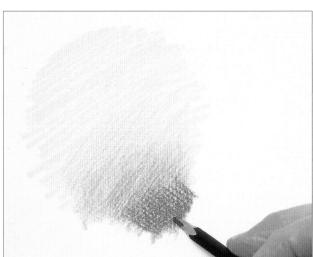

ARTIST'S NOTE

While blue is very useful for darkening many colors, it does not work on yellow, instead it creates green. Black contains an element of blue, so it would also tend to produce green when applied over yellow. In general, try to avoid the use of black, even for the darkest areas.

Add purple again to deepen the tone even more. Notice how much richer a combination of different colors, layer upon layer, is than a single color applied on its own. Similarly, painters traditionally obtained deep glowing tones by adding layer upon layer of transparent glazes of different colors.

How can I draw a convincing symmetrical object?

A symmetrical object such as a bottle, plate, or vase can look wrong in a drawing if one side is not a perfect mirror image of the other. Even if it is slightly wrong, as long as the other side is an accurate mirror image, the drawing will look convincing. In order to achieve perfect symmetry, follow the simple method below.

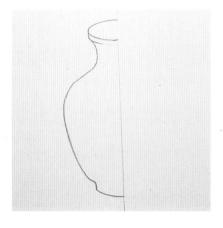

Lightly draw a vertical line to represent the mid-line of the vase. This joins the midpoints along the top and bottom of the vase. Now draw the contour of one side as accurately as you can.

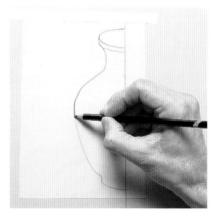

Place tracing paper over the drawing, sticking it down with masking tape to keep it from slipping. Trace carefully both the midline and the contour. Use a soft 3B pencil so that the graphite comes off the tracing paper easily in the next step.

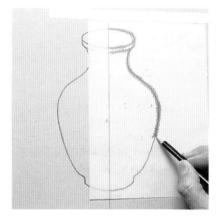

Turn the tracing paper over, and—superimposing the midline and the top and bottom of the vase over the original drawing—redraw the contour you have just traced. Use a harder HB pencil to do this so that your tracing is fully transferred to the drawing.

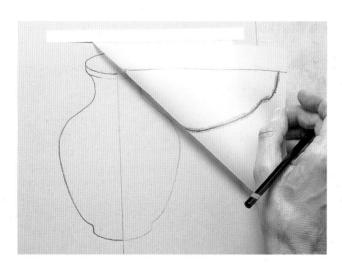

Lift off the tracing paper to reveal the other side of the vase. This imprint will be an exact mirror image of the side drawn originally.

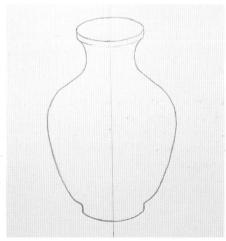

Draw over the new imprint to reinforce the image if necessary. Don't feel you *always* have to draw with perfect symmetry. Misshapen objects sometimes have a charm of their own.

What different types of shading are there?

How you shade depends partly on the drawing implement you are using but also on the mood of the drawing and the way you feel it should be. A rapid sketch in charcoal is likely to be shaded by little more than a hurried scribble or smudging with the finger, while a careful, measured drawing—perhaps using pen and ink—may be crosshatched systematically to create shading.

HATCHING

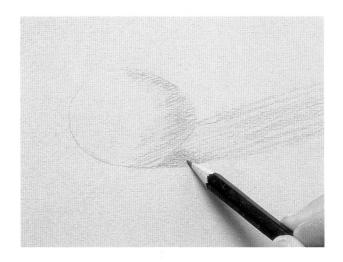

These crayon strokes are all parallel to each other. Draw some strokes with greater downward pressure than others, giving thicker, darker lines. Only those drawing implements that can deposit variable amounts of pigment, such as pencils, charcoal, chalk, and pastels, can achieve this effect.

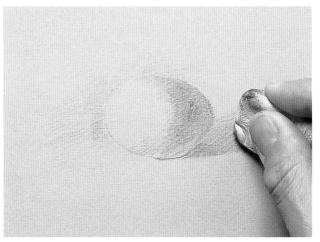

Shade in the background behind the light side of the egg to make it stand out better. Then, simply shade around the dark side of the egg and its shadow on the tabletop to give solidity to its form. Use a kneaded eraser to remove excess shading (see Artist's Note, page 21).

CROSSHATCHING

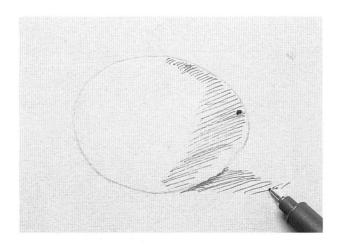

Start by drawing lines parallel to each other, as with simple hatching, above. You can use any drawing medium, although this is one of the few shading methods possible with pen and ink. In this instance, use a 0.3 technical pen.

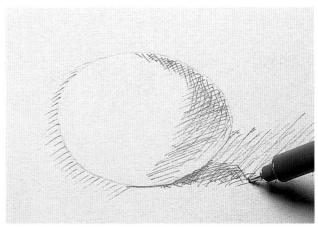

Create a darker region by hatching a second layer in a different direction. Obtain increasing degrees of darkness by adding more layers of hatching, each in a new direction. Traditional print-making methods, such as engraving and etching, also rely on crosshatching for shading.

SMUDGING

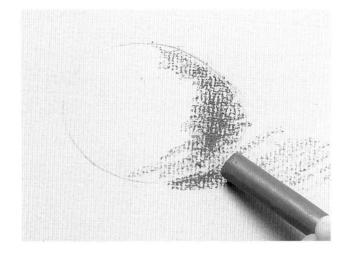

Particularly effective with charcoal, soft pencils, or crayons, smudging is a quick method for smoothing out soft pigment over large areas. Draw charcoal over the shaded areas, applying greatest pressure where there is deepest shadow.

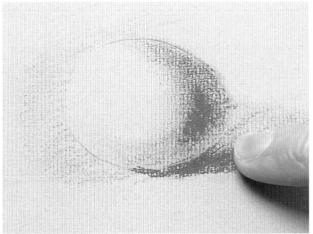

Use your finger to push the pigment around and into the grain of the paper. This is likely to be very messy, and it is advisable to have a damp cloth handy to clean your fingers to avoid inadvertently leaving marks elsewhere on the paper.

STIPPLING

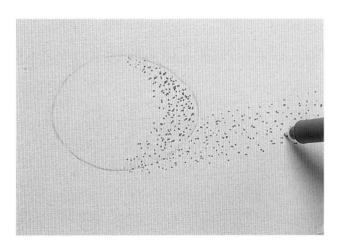

Stippling cannot easily be done with a pencil. Implements that deposit liquid ink onto the paper are the most effective. Technical or anatomical drawings benefit from the high degree of subtlety achievable by stippling with pen and ink.

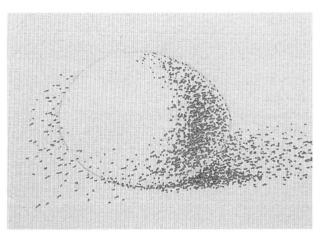

There are no intermediate shades with stippling, so none of the gradations in the shading are lost. Use a 0.5 technical pen to produce thicker dots than the 0.3 pen in the crosshatching demonstration.

ARTIST'S NOTE

A kneaded eraser is useful for removing pigment from the paper. Just press it onto the drawing; when removed, it takes away some of the pigment. Shape the eraser into a sharper point for finer areas. A kneaded eraser is also useful for cleaning up your final drawing by removing unsightly smudges on the surrounding paper.

SCRIBBLING

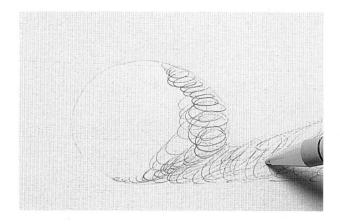

Use a rotary motion for a fluid, free style. A ballpoint pen is the best implement to use. However this technique is not suitable if a high degree of realism is desired.

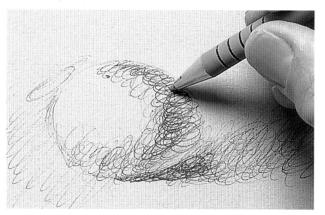

Make additional scribbles to produce the shading in the deeper shadows. Make secondary scribbles with more rapid turns of the pen to create smaller circles, which cover the paper more quickly (in effect, creating a rotary crosshatching).

BURNISHING

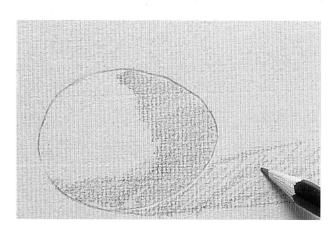

Burnishing is the rubbing of white over existing shading to produce a shiny texture and smoothe out irregularities in the original shading. It is optional and is done after all the regular shading has been completed.

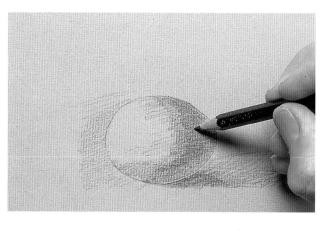

Shade and define the darkest areas with a pencil. So far, the gradations from thin to thick shading are very crude. You may be happy to leave the drawing at this stage—this will depend on the size of the picture, the time available, and the degree of "finish" that you wish to achieve.

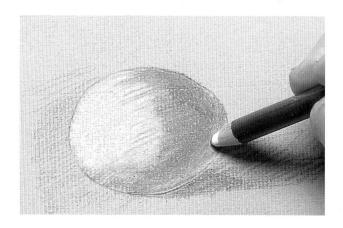

Add Chinese white to make the tone of the lightest part of the egg paler than that of the paper. Burnish the lighter shading first, leaving the darkest areas until last.

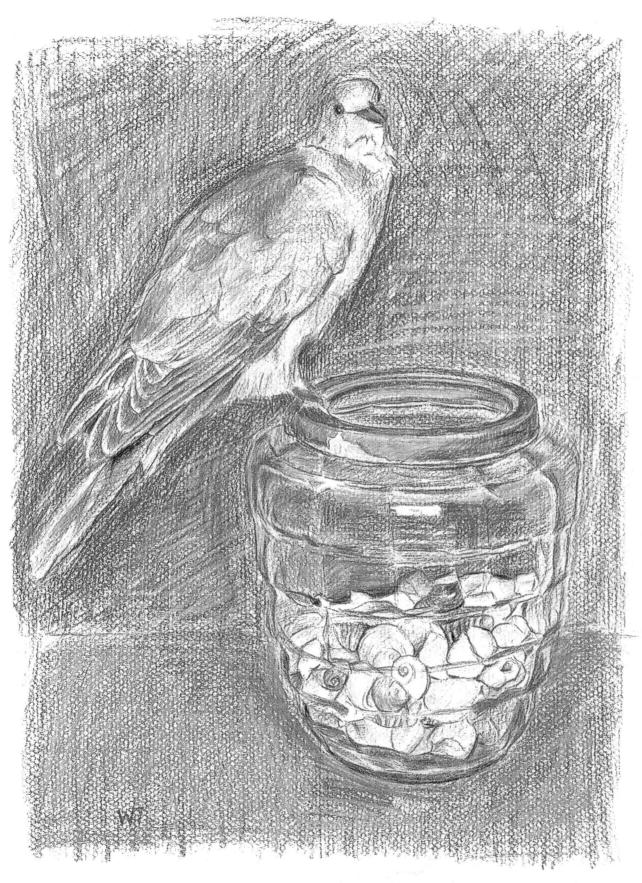

Above *Still life with bird* by Will Topley shows color overlays built up with loose hatching and shading. The heavy grain of the paper contributes an open, free quality to the color mixes, but the layering of colors makes an attractively descriptive image conveying different kinds of textural detail.

Q

What is meant by drawing "sight size?"

Drawing "sight size" means that your drawn image, when held up at arm's length, is exactly the same size as your subject. It provides a quick and relatively easy way to ensure your measurements are accurate. Holding your pencil at arm's length, position it so that its tip is at one far edge of your subject. Then place your thumb where the opposite edge of your subject finishes. This marks the width of your subject.

All measurements can be taken this way. For extra accuracy, it can be helpful to use a ruler instead of a pencil and actually measure your distances in inches or centimeters.

First, establish the size of the subject before transferring it to the paper. A ruler measurement shows that the width of this drawing is 5 inches (12.5 cm), so select a sheet of paper considerably wider than this.

The horizontal width of the top tile is 3.5 inches (9 cm). Plot this on the paper. This measurement can serve as a reference for all future measurements. Although "arm's length" should be constant, it seldom is because of slight shifts in your position, tiring of the arm, and so on. Each time you take a new measurement, check that your arm is held correctly by referring to this length.

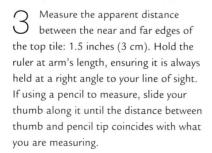

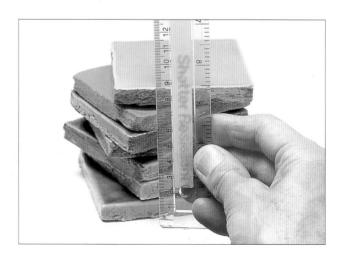

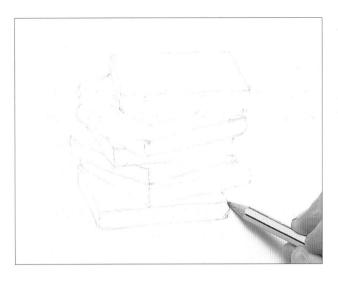

Once you have taken a few "landmark" measurements, you can judge the rest by eye alone, depending on your confidence and on the accuracy to which you want to work. Some artists use this method for almost every measurement, others hardly at all. Nevertheless, it is good practice to train yourself to see the proportions in front of you and to discard the ruler, especially for quick sketches.

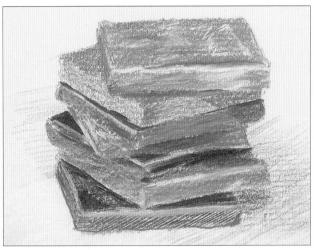

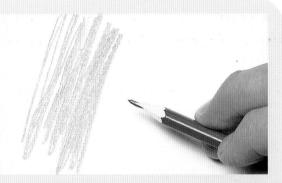

ARTIST'S NOTE

A quick way to obtain a very sharp point on a pencil is to stroke it back and forth at a low angle on to a rough-grained sheet of paper, rolling it in your fingers as you do so. It takes only a few seconds and should be repeated frequently while undertaking very delicate work.

Hold the picture up at arm's length next to its subject to check that the picture is "sight size." The size of your drawing should be the same as that of your subject. If you like to use this method but would like a larger final drawing, you can double or triple each measurement to achieve a drawing two or three times the size of the original subject.

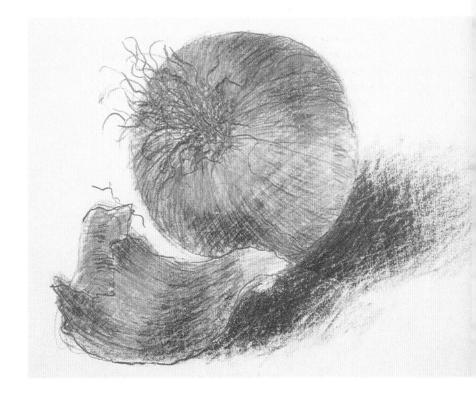

Right In this drawing of an onion, graphite lines and shading describe the basic shapes, texture, and dark shadow, while the colored pencils contribute local color and highlighting.

Demonstration: Baseball cap, bat, and glove

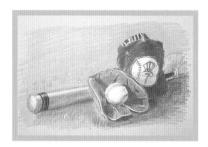

A simple still life, such as this baseball equipment, demonstrates a number of the techniques explained in this chapter. The materials needed for this drawing are very simple: a sheet of good-quality paper taped to a drawing board, a pencil, a ruler, an eraser (which may not be used, but have one handy just in case), and a set of good-quality colored pencils. The baseball items were set up on a

table and lit from the left, and the drawing board rested on another small table in front of it.

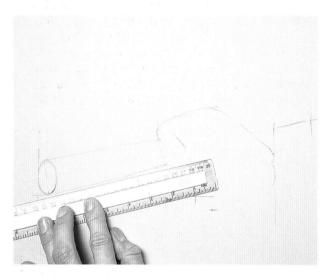

Draw the picture "sight size" (see page 24). Take some measurements and mark the positions of the bat and glove on the paper. Establish the angle of the bat by aligning the ruler with the bat and carefully transferring it to the drawing, ensuring its angle is maintained. The end of the bat, at the left of the drawing, is positioned on the paper with no difficulty, but what about the glove and hat? By holding the ruler horizontally in front of the still life, it is obvious that the bottom of the cap lies just below the top of the bat at the left. So draw a faintly ruled horizontal line in the corresponding position across the page so that the height of the cap is known.

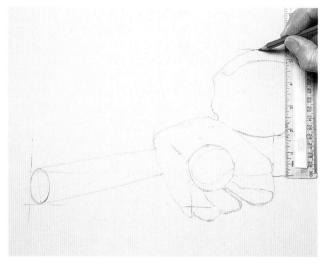

Measure the distance from the bottom of the cap to its top with the ruler held at arm's length. It is just under 5.5 inches (14 cm). Mark the top of the cap using this measurement.

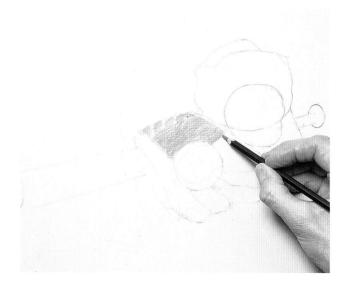

Now that most of the contours are established, color the glove blue. It does not matter where you start coloring, but it can be helpful to begin at the focal point—in this case, the glove and ball.

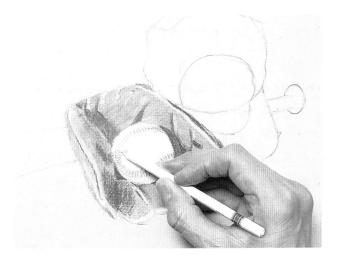

Hatch some light violet over parts of the blue glove, and use a darker blue to stress the shadows beneath the ball. Draw the brown stitching of the ball before adding the white. It is usually better to fill in a background color after detail such as this has been drawn. Carefully fill in with Chinese white, avoiding going over the brown stitching. The advantage of using toned paper is that it can be both lightened and darkened. Some of the brown stitching may become hidden by the white, but pictorially this is preferable to adding the stitching afterward.

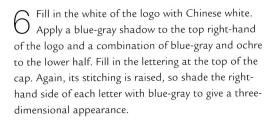

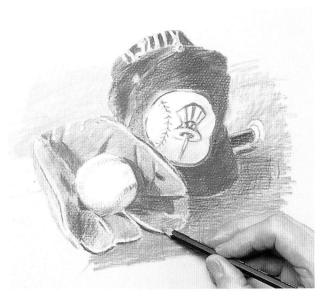

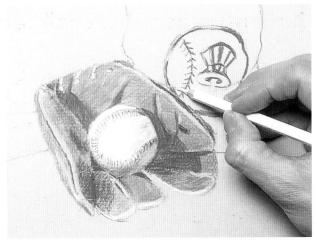

Tone down the white of the ball with ochre for the shadow. Darken the lowest part of the ball with a mix of dark blue and blue-gray, and use pale blue to its right. This is largely caused by reflection from the blue glove. The red stitching of the cap's logo is raised and catches the light on its left side. Add Chinese white to the left side of the stitching to lighten it. The right side of the stitching is in shadow and appears darker, so use a deep red here.

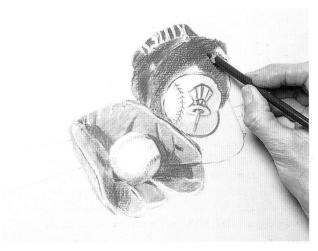

A large shadow falls down the right side of the cap, so underdraw this in crimson and purple. As the blue is drawn over the shadow, it is instantly darkened. The shadow could equally have been colored with brown, but since the main color theme of this drawing is red, white, and blue, a red underdrawing harmonizes better. The handle of the bat peeks out from behind the cap. Check its exact position with a ruler to ensure it lines up with the rest of the bat drawn previously. Its color is black, but the top part catches the light, so rub over it with Chinese white.

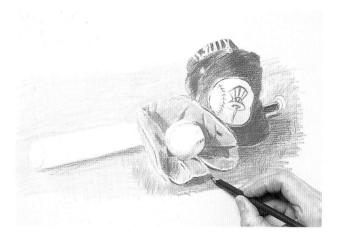

Although these items are set up on a tabletop, you will need to imagine they are on grass. The extent of the shadow cast on the tabletop by the cap and glove (lower right) serves as an indication of the amount of grass you need to draw.

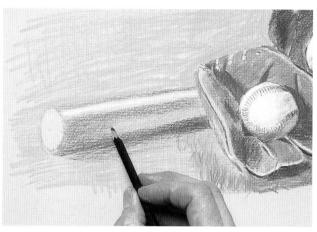

The other end of the bat has a metallic finish. Achieve the typical metallic luster by careful observation of the tonal variations around the bat. An imagined green reflection on the bat replaces the pale reflection of the tabletop. Tone down the green shadow underneath and on the bat with dark blue. Avoid using a darker green because a mixture of colors achieves a better result than a single color.

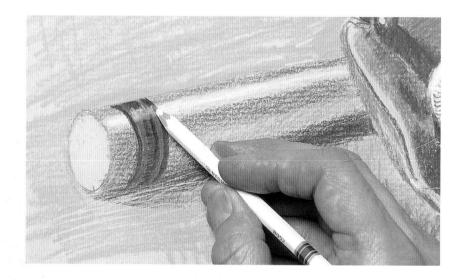

Color the black and red stripes at the end of the bat to show the same tonal and color variations seen in the real bat. This is one of the rare occasions on which a black pencil is used because it is imitating something that is intrinsically black. Lighten the part that reflects the light with Chinese white.

Rendering the impression of grass from memory is not easy, so make a start by inserting blue-gray strokes, which will serve as the shaded sides of grass blades.

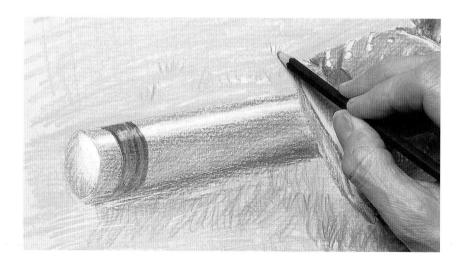

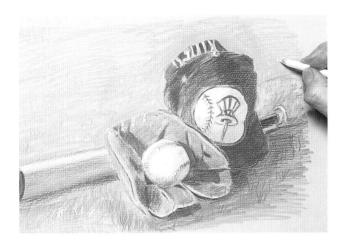

12 Using Chinese white, add paler sides to the grass blades facing the light. Because it is drawn from the imagination—and therefore likely to be unrealistic—it is important not to be too fussy with the grass so that it doesn't detract from the main subject of the picture.

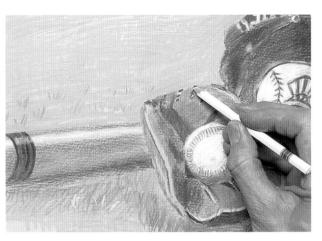

Return to the finer details, such as the lacing of the glove. Use black here because this is the intrinsic color of the laces, and add Chinese white for the highlights. It is helpful to look at your picture from different angles and from a distance to see it in a fresh light, especially as you approach the final stages. You will spot any glaring omissions or tonal inadequacies more easily.

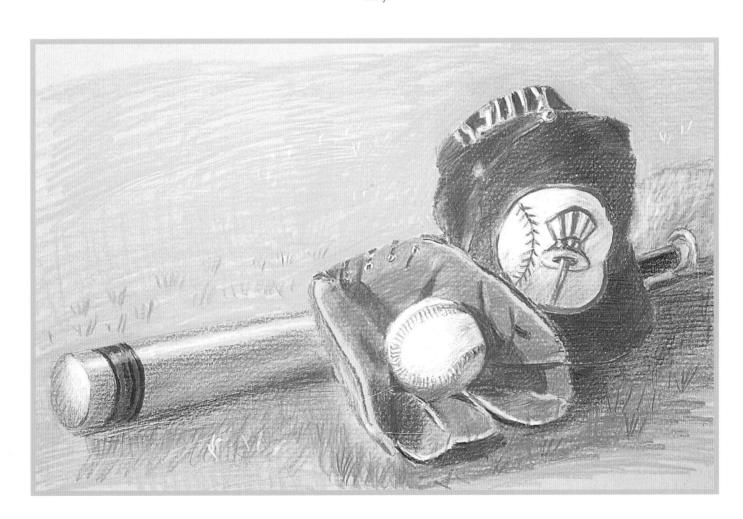

This picture was drawn on a sheet of paper big enough to accommodate the bat, glove, and hat. The drawing does not extend to the edges of the paper, which will make it easier to frame.

The photograph I wish to paint is quite small. How do I enlarge it on my paper?

There are occasions when you may want to make a large drawing from a small sketch or photograph. Perhaps a drawing you made on vacation is particularly appealing, and you want to make an improved, blown-up version. Modern technology can be useful here: a color slide can be projected onto your drawing surface and traced, a favorite method used by artists. Photocopying and scanning, followed by computer enlargement, are all readily available nowadays. However, it may be more convenient to use the traditional method of grid construction shown below.

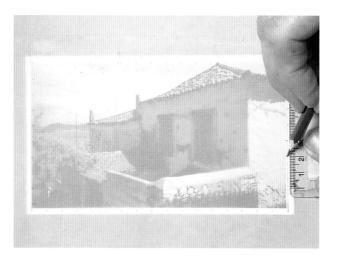

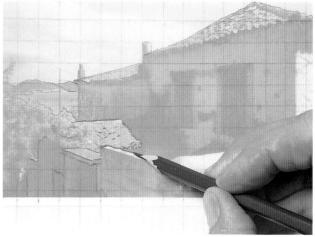

This beautiful photograph of a Greek island cottage is to be enlarged to twice its dimensions. To do this accurately, draw a grid of squares, each ½ inch (1 cm) by ½ inch (1 cm), on a sheet of tracing paper placed over the photograph. Use tracing paper so that you do not spoil your photograph.

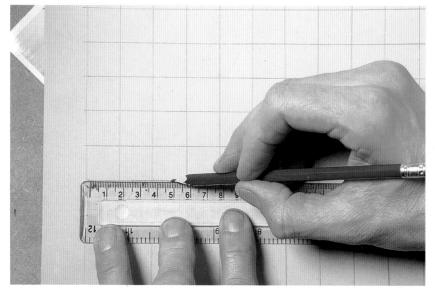

Plot a similar grid on the paper on which you want to draw. Here, however, each square is 1 inch (2 cm) by 1 inch (2 cm) so that the width and height of the picture will be twice that of the original. Bear this in mind when selecting the size of your paper.

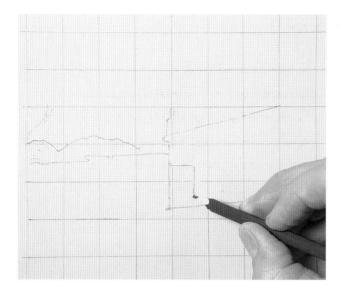

Give the same numbering and lettering system to this larger grid for easy cross-referencing. By examining the small grid over the photograph one square at a time, copy the contents of each square onto the larger grid.

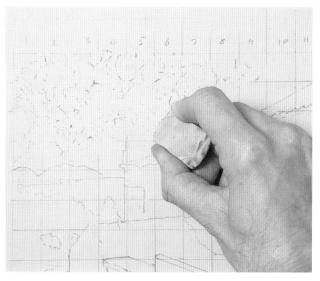

You now have a larger version of the original photograph. Though the dimensions of this drawing are twice those of the photograph, the surface area is four times the original.

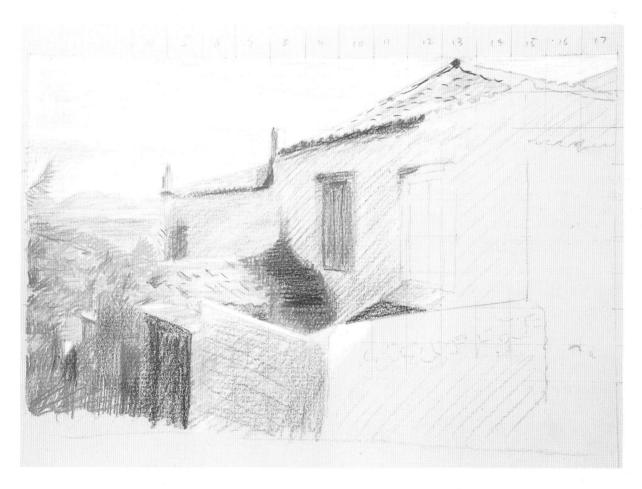

The initial stages of coloring show the comparison between the original photograph and the enlarged drawing. This traditional technique has been used by painters for centuries for transfering a cartoons or preliminary drawings to a canvas. Look carefully at paintings next time you are in a gallery—sometimes the grid lines are still visible through the paint.

What is meant by "negative shapes," and why are they important?

A

The shapes of the spaces left between objects in a picture are known as *negative shapes*. For example, the areas of background seen between the branches of a tree emerge as discrete, flat shapes. Pictorially, they are just as important as the branches themselves because they take up as much, if not more, picture surface. If you concentrate on these negative shapes, you will find the outlines of the branches gradually emerge. The same applies to the spaces between the objects in any other subject you draw.

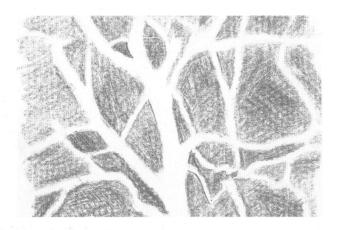

The areas filled in pink have exciting abstract shapes.

Concentrating on these negative shapes forces you to look much harder than you would if drawing the branches alone.

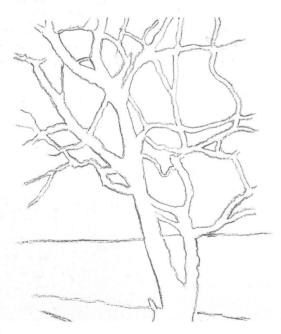

Draw the same tree, and give equal attention to the negative spaces and branches. The interlocking pattern of shapes ensures that the background and branches have equal importance pictorially. Include some of the trunk and horizon to show the tree in the context of its surroundings.

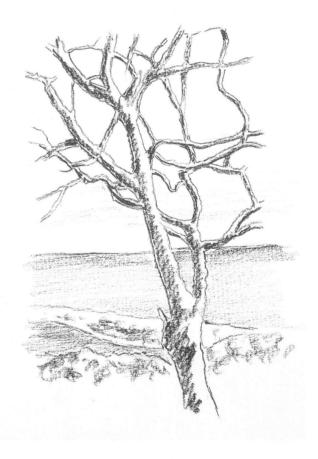

Shade the branches to give them form. Their relative positions in space will become apparent. This more realistic drawing still has the same exciting shapes between its branches because it has been built up from observation of these very shapes, rather than from the more predictable branches.

What is linear perspective?

This is simply the way in which parallel lines that recede into the distance all appear to meet at a single point, known as the *vanishing point*. When a building is viewed straight on, the window ledges, doors, and the top of the roof are usually all horizontal and parallel to each other. When viewed from an angle, however, all these features—when extended into the distance—converge at a vanishing point. Other vanishing points are likely to be present as parallel features recede in other directions. Verticals also have a vanishing point in the same way.

VANISHING POINT _

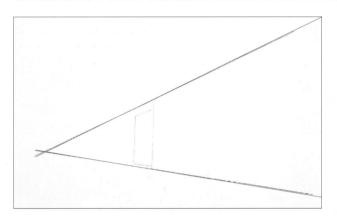

First, establish the angle of slope of two parallel features, say, the top and the base of a building. When these are extended by ruling lines to the horizon, they meet at the vanishing point, shown here in red.

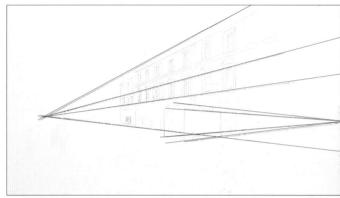

The angles of slope of the window ledges and the roof will simply lie along lines drawn from these features to the vanishing point. An understanding of this principle will save you a lot of time because it avoids the necessity of laboriously measuring out the angle of every slope that you want to draw.

VERTICALS

Verticals, such as a building's edges, or the sides of a window, have a vanishing point high up in the sky. If you are sufficiently far away, such verticals appear virtually parallel, that is, with a vanishing point almost infinitely far away.

However, the closer you get to a building, the nearer the vanishing points. When you look up from the ground at a tall building, the verticals appear to converge above your head. Such apparent distortion is often unacceptable in a picture, and artists usually ignore it keeping all verticals parallel.

Is there an easy way to draw objects receding into the distance?

A row of columns, street lights, floor tiles, or any other regularly repeating pattern can, of course, be laboriously measured out. However, as long as they recede from you in a straight line, you can plot their positions as shown below. This is a time-saving technique, and you may find it will be needed surprisingly frequently for outdoor drawings, interiors, and even still life.

In the foreground is one of many steel columns that supports the roof of a large railroad terminal. Draw the edge of the platform and the other more distant columns. Take great care when finding the angle of apparent slope of the platform edge, since the whole picture will rest on this.

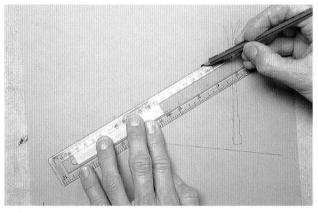

O Join the tops of the near and distant columns with a ruler so that the tops of all the other columns fall along this line. This line crosses the previous line at the vanishing point. Now measure the distance between the first and second columns, and draw the second column.

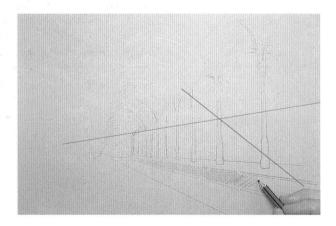

Now rule a new line exactly mid way between the two converging lines that you have already drawn, shown here in red. Also rule a line starting at the bottom of the nearest column to cross the middle red line at the point at which it meets the second column, shown here in blue. Continue this line until it meets the top line. This is the position of the third column.

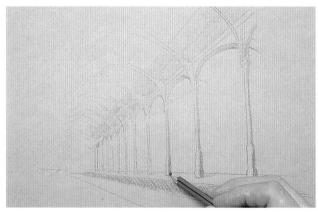

Repeat this process until the positions of all the columns are in place. This is a much easier method than tediously measuring the distance between each column, which would give a much less accurate or convincing result: you can see that the distance between the columns decreases with distance.

When is it acceptable to draw straight lines with a ruler?

In general, it is best not to draw straight lines with a ruler, except for constructional purposes. In a drawing in which curves and other contours are drawn freehand, a ruled straight line will look out of place. It will appear simply as that—a ruled straight line—and will not provide the desired illusion. Moreover, If the line has been ruled even slightly inaccurately it will make the situation even worse. However, ruling faint guidelines can be helpful as long as they are then drawn over in freehand. The examples below show the difference between the same townscape drawn first with a ruler then without.

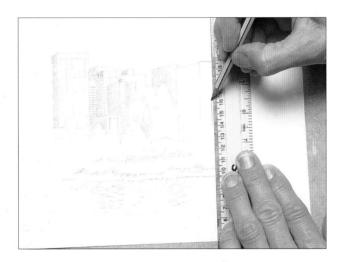

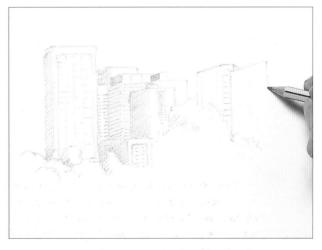

There is virtually no margin of error with a ruler. Say you are drawing a line that has to be parallel to another line—two sides of a building, for example. If it is ruled slightly off-parallel, it will be noticed immediately. In this drawing, all the straight edges of the buildings are being drawn with a ruler.

Some lines have deliberately been drawn slightly out of place and stand out as being wrong. These ultra-straight lines are inconsistent with the loose way in which the trees and riverside shrubs are drawn. A drawing is more convincing if it has been executed entirely in a single style. Here, all the straight edges of the buildings are drawn freehand. Do not be afraid to draw a straight line without a ruler—the secret is always to look ahead to where the line should ends.

Here, the inevitable wobble of the freehand lines is consistent with the treatment of the foliage, giving the drawing a more coherent whole. The buildings look more solid and the scene takes on a more realistic appearance.

D

Demonstration: Landscape with barn, fence, and road

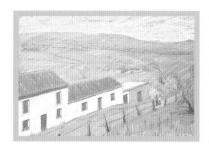

To draw on location is a rewarding experience because it forces you to look and see what is really in front of you. While taking painting equipment and materials into the field is cumbersome and can pose logistical problems, a drawing pad and a box of pencils couldn't be easier. This scene is of a village in southern Spain and illustrates techniques that arise when drawing out of doors. Choose a day

on which the weather conditions are unlikely to alter. To have to stop work because it starts to rain or to find that all the colors change as bright sunshine takes over from an overcast sky can be difficult to deal with.

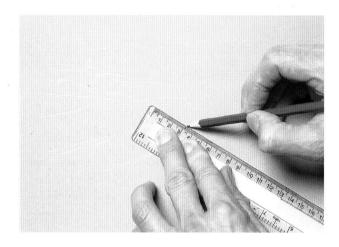

Slant the ruler at the correct angle shown to render the sloping roof. Determine this by matching it with the angle of the actual roof and transferring the ruler to the paper, keeping its angle constant. Establish the other slanting edges of the building using this method.

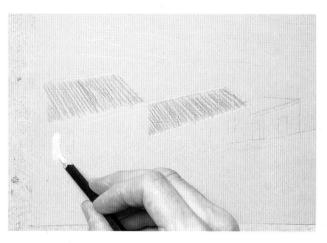

The focus of this picture is the building, so tackle it first. The toned paper enables you to add white as well as darker colors, such as the brown of the roof tiles.

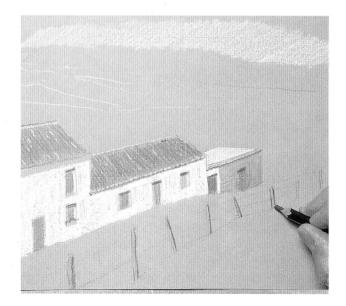

Color in the white wall but leave gaps for the windows and doors, which can be completed at a later stage. Include a dash of bright color—two red doors—to establish a feel for the picture. Some white hatching also indicates the pale sky. When drawing the fence posts, make sure that the interval between them decreases as they recede into the distance.

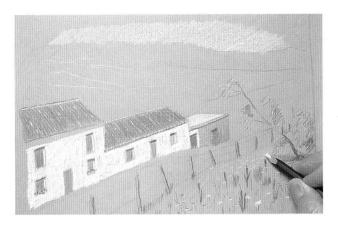

Sketch the foliage of the trees on the right using a combination of pale green and blue. Draw the background around them, filling the negative shapes between. Lay down a preliminary green color for the meadow, which you can tone down at a later stage. Roughly draw in some individual flower heads and stems. This meadow takes up a large fraction of the picture surface, so it must be drawn carefully. Always give attention to the foreground. If it is badly drawn, your picture is likely to be spoiled.

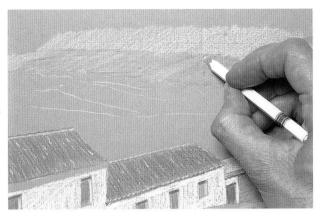

Color the distant hill with a mix of light violet and blue. Work some Chinese white over it to make it paler and also to intensify its color. Aerial perspective is in operation here—the blueing and lightening of a landscape as it recedes into the distance (see page 68).

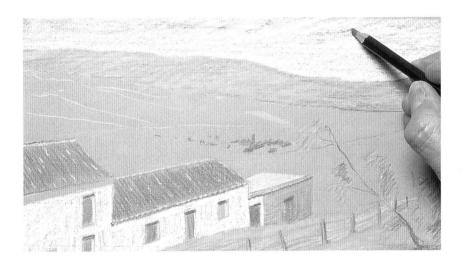

Cover the sky with Chinese white followed by a layer of blue. Lay down the beginnings of the farmland in the middle distance. Do not hesitate to jump around a picture. Add whatever catches your eye—one area does not have to be finished first before you start another.

Now back to the farmland. Darken it all over with a blue-gray pencil. Keep looking at the relative tonal values of the different parts of your drawing, always comparing them with the real thing in front of you. Looking from one thing to the other will show you what your drawing lacks. Color the distant fields to the right in blue and purple, and use Chinese white to lighten their tone. Their great distance gives them a blue tinge, not so different from the distant hill line.

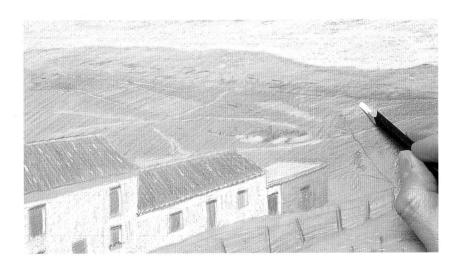

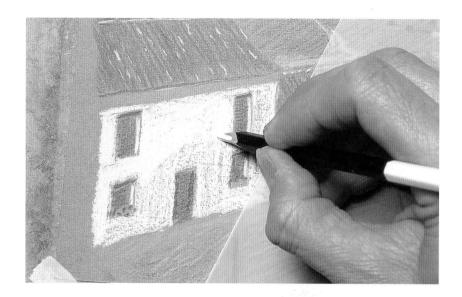

Now that the picture is taking on a life of its own, it is obvious that the house in the foreground is not white enough. Force Chinese white into the grain of the paper with increased pressure, and color the doors and the shutters of the windows with a mixture of green and blue-gray.

Add more detail in the farmland, such as the hedges beside the distant roads. Remember, though, that detail diminishes in a scene as it recedes. Don't draw more detail than you can actually see.

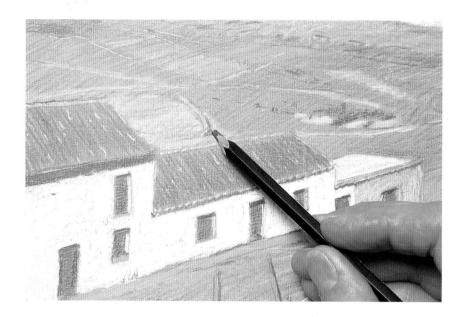

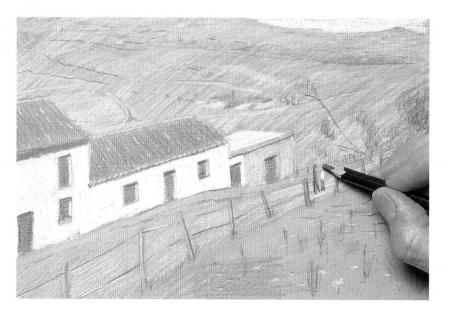

At this stage, the whole of the farmland is too dark and intensely colored. Tone it down with a layer of white. Do not let it become lighter than the distant hills that are farther away. To liven up the scene and to introduce a human element, add a couple of figures, but not obtrusively. A figure or two will often add interest to a picture. These two are deep in conversation. They help to set the scale of the composition and draw attention to the road that was previously rather dull. Don't be afraid to add elements to your drawing if you think they will add interest.

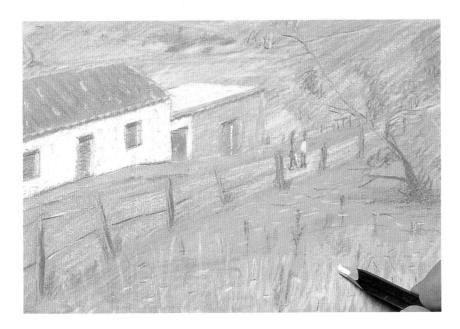

Add more yellow to the farmland, particularly some of the nearer fields. This will make them contrast more with the distant, bluer fields, enhancing the feeling of space. To finalize the meadow, indicate pale grasses in the foreground with strokes of white. Loosely hatch a number of darker colors over large areas of the meadow to tone down the general background color.

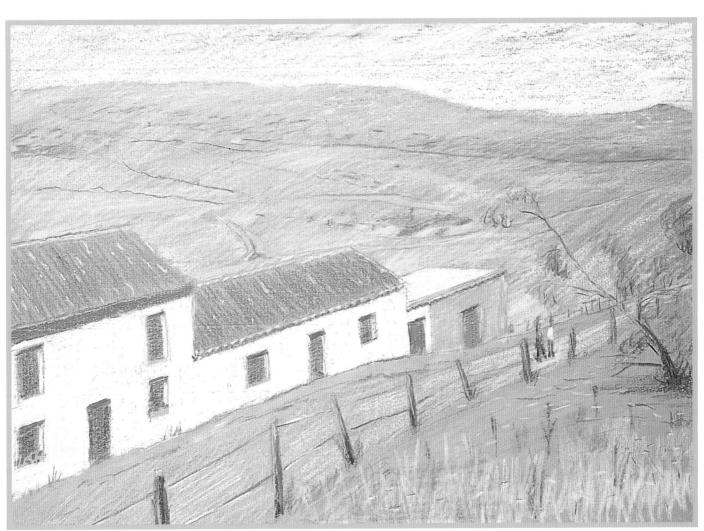

This is the kind of landscape that you can draw fairly quickly while on vacation. It provides a better memento than a photograph because you have been forced to interpret every little bit of the scene in front of you.

one of the joys of drawing a still life is that you are completely in control. You choose all the objects and the color scheme, arrange the composition and the lighting, and take as long as you like on the drawing—what can go wrong? Well, plenty, of course, but these are some of the practical advantages of a still life. It gives you the opportunity to explore form—the three-dimensional shape of objects—and how to depict it on paper. Why does shiny metal look as it does? What is it about the appearance of glass that enables us to see what it is at a glance? By finding the answers to such questions, you are in a stronger position to represent these textures on paper.

What objects should you choose to draw? There are no rules here, so anything can be used, ranging from the mundane—kitchen utensils, garage tools, old shoes, or orange peel—to the exquisite—vases, statuettes, a silk scarf, or the best china. Whatever you decide on, you will see them as you've never seen them before. Being forced to look at common or unusual objects will be an eye-opener both for you, and, hopefully for those looking at your drawing.

Some "still life" is not quite as still as you may wish. Flowers, for example, turn toward the light, droop, drop petals, and so on, so you have to work fairly quickly. However, flowers are among

the most rewarding of natural subjects to draw, with their infinite variety of shape, texture, and color. Fruit, vegetables, and fish are other favorite subjects for the still-life artist and have been for centuries. Look at the drawings and paintings by the great Dutch artists, for example. Because there is never any hurry with most still life, it is a good subject with which to experiment the various techniques available to the artist. Try using different types of pencil, charcoal, chalk, and pen and ink. Try using colored pencils and then perhaps experiment with pastels.

You can learn about composition with still life because all your chosen objects can be moved around until the arrangement looks just right. If you look at your setup through a frame, you will get a good idea of the finished drawing. Many artists always use a frame to compose their pictures when working from life. The lighting can be altered too—a single light source placed in front, at the side, or behind your setup will give very different effects.

A still life can be part of a picture of an interior or may accompany a portrait. In the latter case, objects and possessions associated with the sitter may be entirely appropriate in your picture and give more meaning to the portrait. Similarly, objects relating to the use of an interior will enhance the picture.

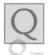

How should I arrange a still life composition to greatest effect?

The placing of objects in relation to each other, and to their background, must be such that they form a dynamic and coherent whole. It is helpful to view your setup through a cardboard frame, so that your surroundings are excluded and do not distract from the focus of your composition. In this way, you can move the objects around until you get a satisfying arrangement within the confines of the frame. Deliberate positioning of objects can look contrived, so try placing them randomly at first, and then look carefully to see what needs adjusting.

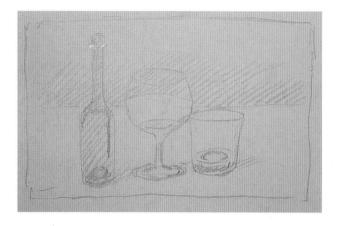

There are endless ways in which to arrange these three objects. In this deliberately poor composition, the far edge of the table falls exactly halfway up and cuts the picture in two. The effect is accentuated by the rim of the tumbler touching this line. Also, the edge of the tumbler just touches the wine glass—another uncomfortable pictorial arrangement that is best to avoid.

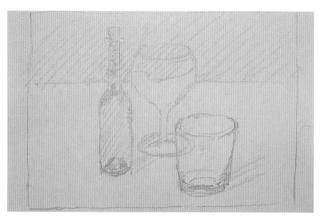

Place your objects at varying distances from your viewer, and overlap them to give more depth to your picture. The tumbler in the foreground balances the larger form of the bottle. The wine glass forms the apex of a rough triangle, enabling the objects to relate to each other in a compact group.

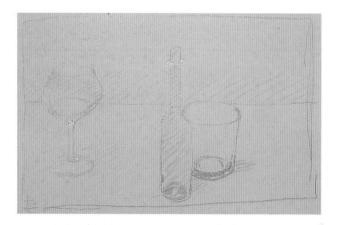

Here, the far edge of the table once again falls halfway up the picture. Additionally, the rim of the tumbler coincides with it, cutting the picture into top and bottom halves, especially toward the right. The centrally placed bottle cuts the picture vertically, and its base touches the bottom of the picture—nearly always pictorially unsatisfactory.

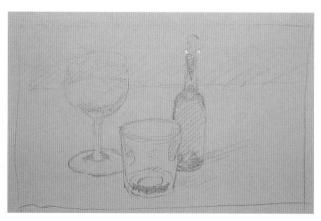

This compact arrangement is visually appealing. The far edge of the table falls above the halfway line and gives the picture a more spontaneous feel. However, if you shift the whole setup slightly to the right, or, alternatively crop a little off the right-hand edge, a much better balance can be achieved.

What are the different ways of illuminating a still life setup?

The way you light your still life setup depends on the mood of the drawing you want to create. Side lighting gives strong shadows on one side of the objects, making them appear three-dimensional and easily recognizable. Each object casts a shadow on the surface on which it is placed and possibly also onto the object next to it. With front lighting, shadows are minimal, and objects appear flat and indistinct. Back lighting can provide dramatic effects, while lighting from above, perhaps at an angle, produces intermediate effects. Whatever type of lighting you choose, it is usually best to restrict yourself to a single light source.

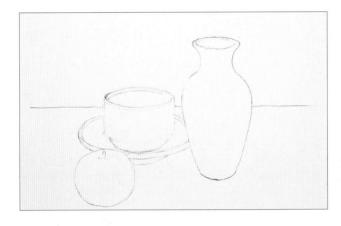

This line drawing has no shading at all and is little more than a diagram. Although all the objects are instantly recognizable, they appear flat and without form. Shade and model the forms to create a sense of depth and solidity.

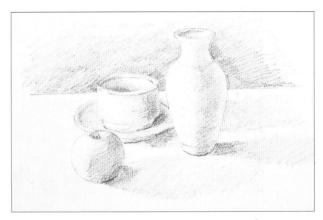

Light from the left leaves the right side of each object in shade, while a shadow to its right is cast on the tabletop. The three-dimensional forms are now more tangible. Use a soft 3B pencil to give intense dark tones.

ARTIST'S NOTE

If you are relying on daylight, remember that a north light is best (or a south light if you are in the southern hemisphere). This is to avoid constantly changing shadows from the sun. If sunlight is an important feature in your picture, spread your drawing over several days at the same time each day.

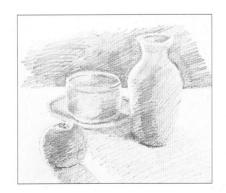

Back lighting casts the bulk of each object in shadow. The light catches only the edges of the objects, creating a dramatic halo. Long shadows lie toward the viewer and help to establish even more forcefully the positions of the objects with respect to each other. Again, use a 3B pencil for any dark shadows.

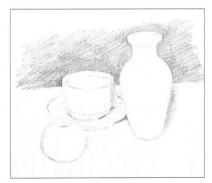

Front lighting gives little to go by in a drawing and is barely different from the line drawing above. Shade the shadows visible at the edges to give the objects form and solidity. Color in a dark background to enhance the objects further.

I have difficulty drawing an ellipse. Is there an easy way to do this?

Ellipses constantly crop up in still life. Any circular shape will appear as an ellipse unless viewed head-on. Plates, bowls, wheels, and also the ends of any cylindrical items, such as the rim of a vase or glass, all assume elliptical shapes when viewed at an angle.

Bear in mind that, just as a circle fits into a square, a square tilted away from the viewer contains an ellipse. The point where the diagonals of the tilted square meet is also the center of the ellipse.

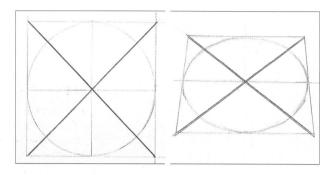

The circle on the left fits perfectly within the walls of the square. The diagonals shown in red intersect at the center of both the square and circle. On the right, the square is seen in perspective, tilted away from the viewer. The diagonals shown in blue now cross more than halfway up. A horizontal line drawn at this intersection represents the diameter of the ellipse.

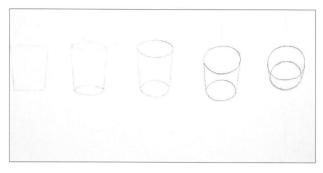

Moving from left to right, the tumbler is seen from a higher and higher viewpoint. The ellipses widen until they become perfect circles when viewed from directly above.

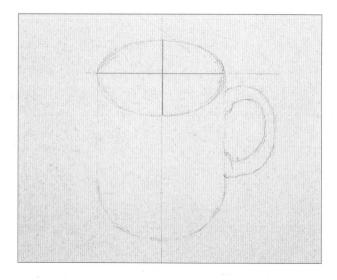

The ellipse at the top of this mug is drawn around two diagonals of a square: shown here in green as vertical and horizontal lines. The wider diagonal of an ellipse (in this case, the horizontal line) lies more than half way up the shorter, vertical line. The lower half of the ellipse appears larger because it represents the nearest half of the mug.

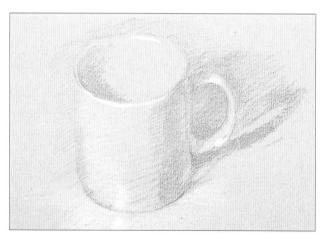

Erase the horizontal and vertical guidelines before continuing with your drawing. Preliminary hatching in one direction represents the part of the mug that is in shadow: the shape of the shadow inside the mug relates directly to the elliptical rim. Hatch the shadow on the tabletop using a soft 3B pencil. Add white reflections to the tabletop using a Chinese white pencil: this creates the illusion of a shiny surface. The open mug top is interpreted as circular because we know it is so, although, drawn from this angle, it actually appears as an ellipse.

How can I create the illusion of glass?

When you look out of a window, the glass you are looking through is virtually invisible. It is only when reflections are seen in it or when features behind it are distorted by refraction that its presence is betrayed. The secret of drawing glass is to transfer these reflections and refractions onto paper. Glass is a popular subject in still life, featuring objects such as vases, glasses, and bottles, with or without liquid in them.

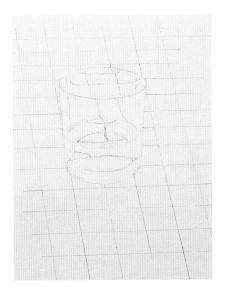

Faintly draw in the outline of a glass, partly filled with water, on a checked tablecloth. Draw the stripes through the glass so that they appear distorted.

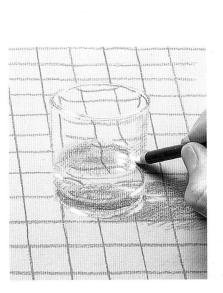

Add some dark, shaded areas by toning and hatching with a soft 3B pencil. Carefully observe and draw the areas of highlight and shadow to give the rim of the glass the appearance of a slight lip. There is a pale patch within the shadow on the tablecloth caused by light reflected onto the shadow.

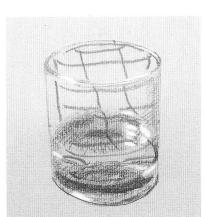

ARTIST'S NOTE The thicker the glass, the increasingly distorted the objects viewed through it appear. Observe the shapes it creates closely, and draw these as accurately as you can so that you capture the quality of the glass object in front of you.

Add white highlights to make the Odrawing spring to life. The advantage of using tinted paper is that you can add these lighter tones later in a drawing. On white paper, preplan the highlights, leaving those areas blank and toning down everything else.

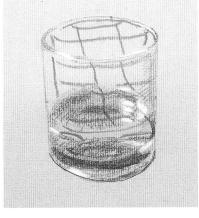

Draw the same glass again but this time without the background. In isolation, the appearance of the glass is rather meaningless. What are those wobbly stripes running through it? Are they imprinted on the glass? Only in conjunction with the background tablecloth does the illusion of glass become clear.

How can I achieve the appearance of polished metal?

Metal objects, such as a silver teapot, a stainless-steel knife blade, or a brass candlestick are frequently chosen as still life subjects. Shiny, polished metal usually has no color of its own. It reflects the colors that surround it.

Drawing metal successfully depends on one's ability to see these reflections and render them accurately on paper in order to create the desired illusion.

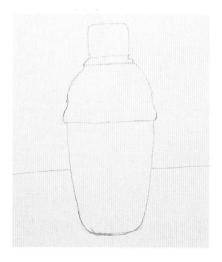

Draw the contour of the cocktail shaker first. This will give no hint as to the material of the shaker. Under some lighting conditions, or if there is little in the surroundings to be reflected, there may be insufficient visual clues to identify the object as metal.

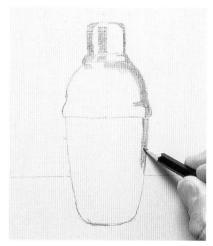

The edges of the shaker reflect the dark side walls of the room, so they are quite dark. Put the shaker into context, and shade in the dark tones, pressing hard onto the paper with a soft 5B pencil. The tinted gray paper will make it possible to add both darker and lighter tones as the drawing progresses.

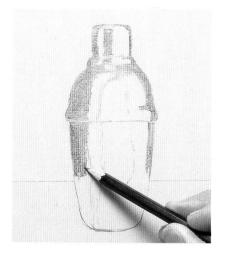

The shaker depicted here is in isolation, but if it were part of a still life, you may find that the deep shadow it reflects is still the darkest area in the picture. Just because an object is shiny, it doesn't mean that it won't be dark-colored. Compare the darkest reflections with those in the surrounding areas so that their tonal relationship is correct.

A Now add intermediate tones, still using a 5B pencil. Press the pencil lightly onto the paper, as opposed to earlier on, when it was pressed hard against the paper to achieve the darker shades. If you want to achieve darker tones use even softer pencils, such as 6B, 7B, and so on.

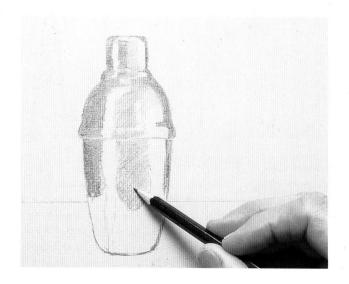

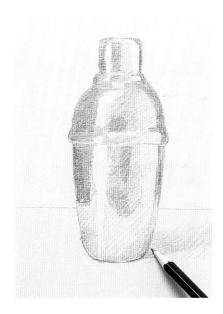

The main light source is high up to the left, casting a short shadow to the right of the shaker. Incorporate this into your drawing so that the object's relationship with the surface on which it is standing is established. Take care to render the shape and extent of the shadow correctly; otherwise, it may not make correspond to the reflections on the metal.

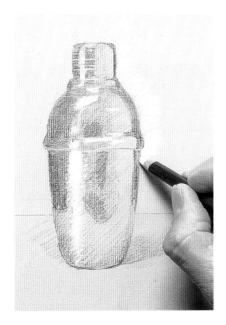

Hatch the background with Chinese white so that it contrasts sharply with and accentuates the dark sides of the shaker. You should always include some kind of background, even just a little shading, so that the object has something to relate to.

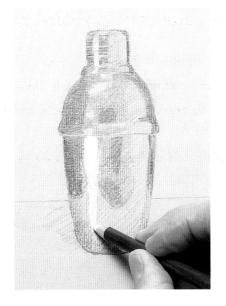

ARTIST'S NOTE

The more tarnished a metal is, the more vague and suffused with white (or pink in the case of copper) its reflections are. The lights and darks are still there, but less marked—the highlights are not so bright and the deep shadows not so dark.

Add the lightest highlights with Chinese white so that the highly polished nature of the metal becomes apparent. It is the close juxtaposition of extreme light and dark which is characteristic of a metal's surface. A flat knife blade or a flat silver tray will not appear as metal if it reflects only one tone from—say, a plain ceiling.

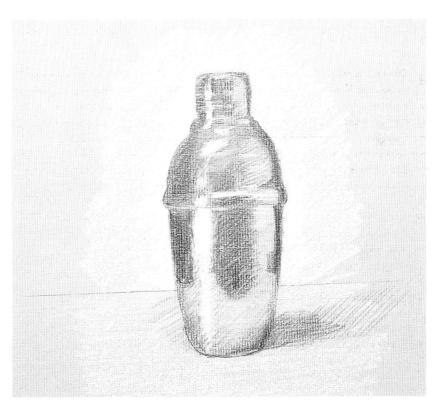

Having burnished most of the metal and the shaker's shadow on the tabletop using an overlay of Chinese white to create a glossy surface, smooth out most of the pencil hatching with a finger to help accentuate the polished appearance of the metal. The finished drawing looks very realistic, simply as a result of faithful "copying" of the main features of the real object.

Demonstration: Fruit in a copper pot

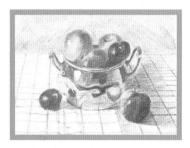

Unlike a landscape or an interior, you can set up a still life exactly as you want. You can choose the background and take time adjusting the objects until you are perfectly satisfied with the arrangement. You can experiment with different lighting, compositions, and props. And once you have started your drawing, you know that you can take as long as you like because your setup will not change drastically—unless you are

drawing fresh flowers. This pot of fruit is in the corner of a room with white reflective walls behind it and to its right. It is lit by a single electric lamp to the left.

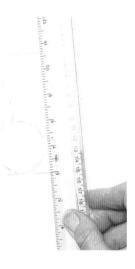

The drawing so far acts as a guide so you can concentrate on the coloring or shading without having to worry about distances and angles at the same time. This is just one way to tackle a drawing, but it is reliable.

Hatch the darkest part of the apple with purple. This is a useful color for darkening both green and red. Avoid using black to create shade except as a last resort because it will deaden and overpower other colors. Add two white highlights in Chinese white: these are the reflections of the lamp illuminating the subject, and their inclusion helps to give a three-dimensional appearance to the drawing.

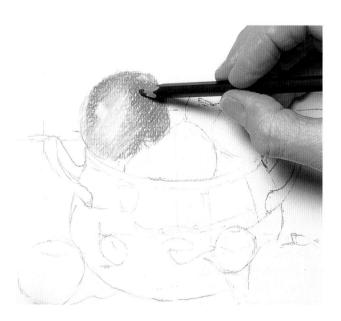

Deepen the red of the shaded side of the apple with dark blue. Shade some of the dark inner side of the pot in brown, and—on top of that—Prussian blue. Use a little white to burnish over the green and ochre areas to produce a shiny texture by smoothing out irregularities in the original shading.

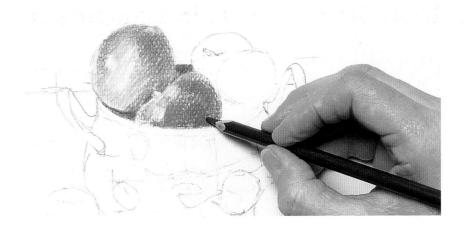

Smudge white highlights into the purple plum. Create the very lightest highlights by drawing with white over patches deliberately left blank within the purple area. The shape of the outline and the positions of the paler parts give the plum its form and three-dimensional appearance.

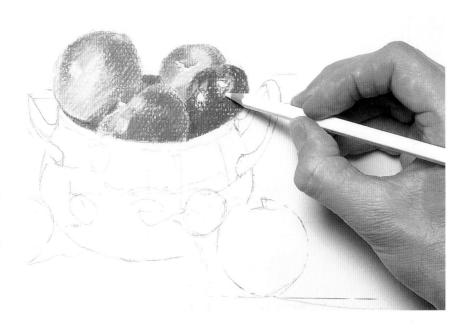

Add some crimson patches to the plums to draw attention to the luminous flesh beneath the skin. Look carefully for such unexpected color. Shade the left-hand plum with purple hatching over the blue, but tone down its reflection in the copper with ochre. Color the reflection of the tablecloth in the copper pot using pink—it can be modified at a later stage where necessary.

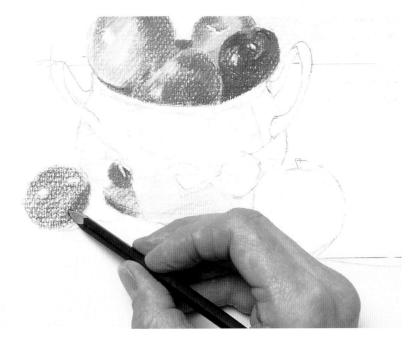

The reflection of each fruit in the convex surface of the copper is much smaller than the actual fruit. Model the apple's reflection with a shadow at its right-hand edge, and place a pale highlight centrally. Add dark blue to the copper to show the reflection of the relatively dark wall behind the artist.

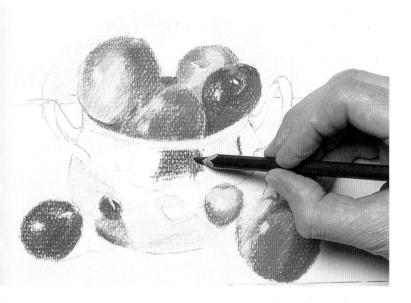

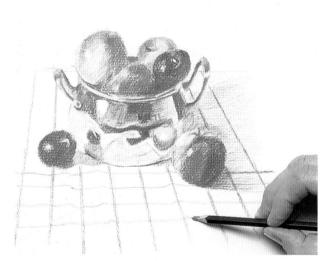

The stripes on the tablecloth all lead to a vanishing point beyond the drawing. Obtain the angles of two of the stripes by holding a ruler up to the subject and tilting it until it coincides with the stripe. Now, with the paper held vertically, transfer the ruler to the stripe's position in the drawing, holding its angle all the time. To obtain the angles of the other receding lines, continue each one to the vanishing point. To find the positioning of the horizontal lines, plot the two nearest lines by measuring them with a ruler held up to the subject at arm's length. Rule a line to pass through one of the newly formed square's diagonals. The points at which it crosses the other lines indicate the positions of the other horizontal lines.

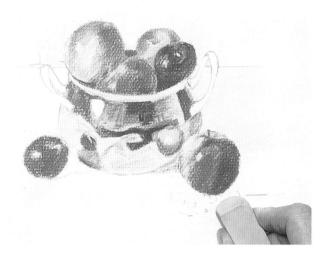

Use an eraser to remove any guidelines that have outlived their usefulness. At this stage, most of the reflections have been included, and the copper pot has already taken on a shiny metallic appearance. With careful observation and the placing of the shapes and colors in their right positions, the metallic look emerges.

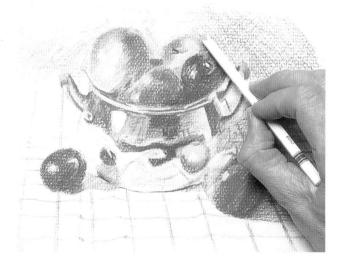

To draw the folds on the cloth, first draw in the relevant horizontal stripes with upward kinks in them. The illuminated side of the fold is paler than the flat cloth, so highlight this with Chinese white. Shade the darker sides of each fold with purple and blue-gray. Similarly, lighten and darken the red stripes at these folds.

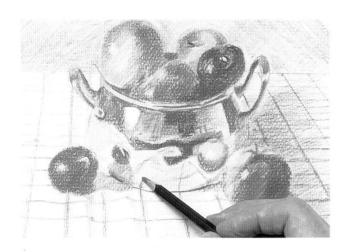

Hatch the white wall background with blue-gray, and burnish it with Chinese white to give it a smoother, less obtrusive texture. This pale wall color is deliberately chosen to be similar in tone to the cloth, so that the main focus is the still life itself. Add the reflections of the red tablecloth stripes to the reflection on the copper pot. Shade the shadow of the pot and fruit on the tablecloth using purple and blue hatching. Color the red stripes in these darker areas with a darker red crayon and, in places, overlay with purple.

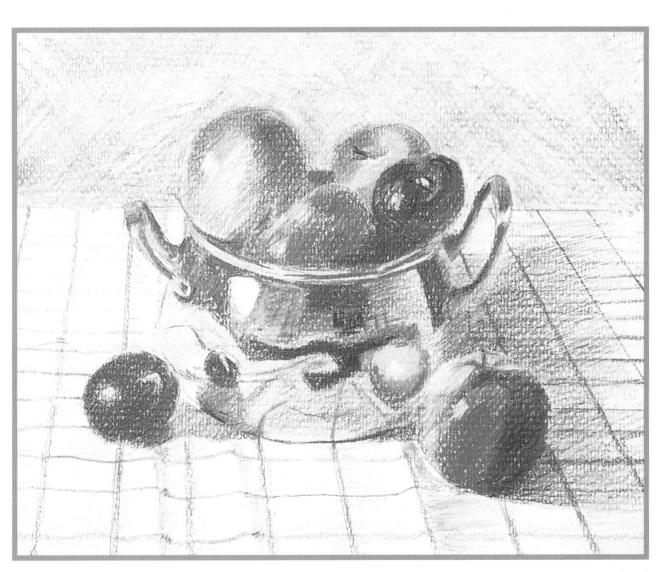

This composition began life as a random placing of the chosen items on the table. After a certain amount of nudging, turning, and juggling of the fruit and pot, this final arrangement was decided. An apple and a plum were left outside the pot to give interesting reflections. These two, together with the prominent apple in the pot (top left), form a triangle that pulls the viewer's eye around the picture. The checked tablecloth provides converging lines that give perspective and depth to the composition.

How can I draw the folds in cloth so that they don't look wooden?

Cloth and its folds are a favorite subject for the still life artist. It is always challenging to create the illusion of a three-dimensional shape on a flat drawing surface. Whether you are drawing the deliberate ironed creases of a tablecloth, the accidental folds caused by ruffling, or the loose hanging of drapery, your approach to drawing should be essentially the same.

A fold in a cloth is likely to catch more light on one side than on the other, and the exact tonal gradations that result should be carefully observed and compared with the tonal values of the rest of the picture.

Before drawing an outline, carefully observe the curves formed by the edge of the drapery and the angles at which the folds fall. Even at this early stage, without any shading, the drawing already gives the illusion of cloth to some degree.

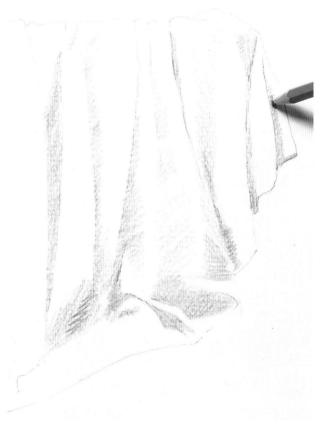

Shading is necessary to give a greater definition of form. Blur your vision to distinguish lighter and darker shades. The lighter parts of the cloth are the turns of each fold, which directly face the light source on the left. Keep these blank at present, and add the darker tones in blue.

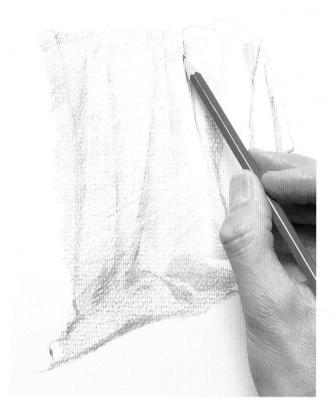

G Lightly hatch over the whole drawing in red (since the cloth is this color), including the blue shadows. The idea is that the blue underdrawing will produce deep, rich shadows in the essentially red cloth. In this case, green is a suitable alternative.

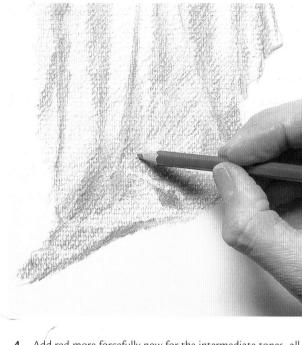

Add red more forcefully now for the intermediate tones, all the while ensuring they do not become as dark as the darkest areas. Keep the highlights clear of color for now.

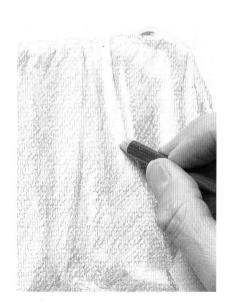

Now add highlights with Chinese white; the drawing will gradually come to life. If this had been drawn on white paper, the highlights would have been left blank. These would be the only areas of white paper still showing, everything else receiving some shading.

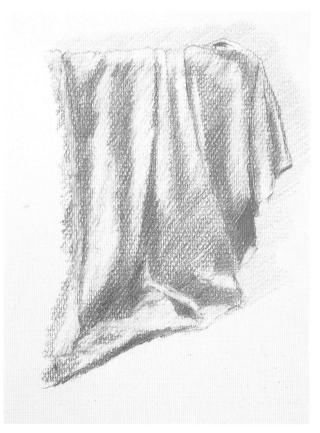

Continuous Intensify the color density with more red and white. One of the joys of drawing with color pencils is their ability to take layer upon layer of color until you are satisfied you have captured the essence of the subject.

What are some ways to draw the texture of different fabrics?

Linen, velvet, and silk are instantly recognizable by sight alone. As with glass and metal, what clues are there about their appearance that enable us to know what we are looking at? With these materials, it is the reflective properties of the fibers and the way they lie that determine the exact pattern of light that reaches our eyes. The fibers may protrude at right angles or lie on the plane of the fabric's surface. The way the light reflects at folds is the giveaway: a perfectly smooth flat piece of fabric is virtually impossible to identify by sight alone.

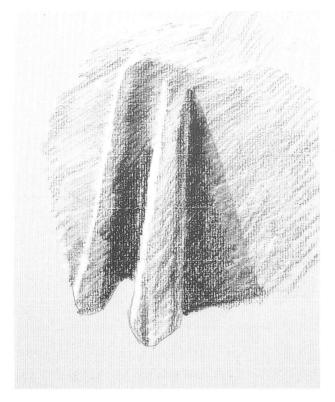

Above The fibers in velvet protrude at right angles. Fibers that are viewed head-on at folds reveal their bases, which are very dark. However, when viewed at a slant, only the light reflected off their sides is visible, hence they appear light. As an aside, the same applies to short-cropped hair, although the overall appearance is different because the fibers are spaced further apart.

Right The highly reflective fibers of silk and satin all lie tightly on the plane of the fabric's surface. In some respects, these materials behave like a polished metal, and this drawing does indeed have a metallic appearance. The smaller secondary folds and kinks in the drapery also give a clue to the thickness of this material.

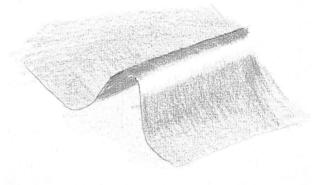

Above The part of a fold of silk that faces the viewer head-on reflects a light source from behind the viewer, giving a highlight at this point. As it folds away from the viewer, darker distant regions of the room are reflected. Hence, the crest of this fold appears dark.

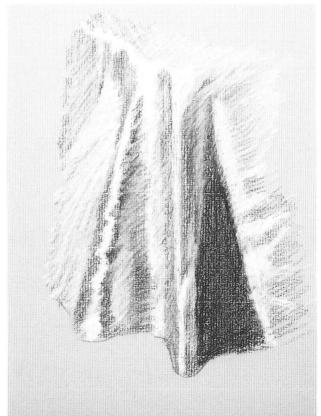

Right Where this fold of velvet is head-on to the viewer, it appears dark; but at its crest, as it folds away from the viewer, the standing fibers reflect the light coming from behind the viewer, and it appears light.

Below This thin, sheer scarf is draped over a pink perfume bottle. As the fabric is semitransparent, whatever is behind it can be partially seen through it.

Where it curves away, it no longer looks transparent but reflects and scatters light, therefore appearing very white.

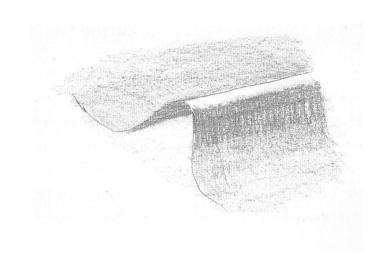

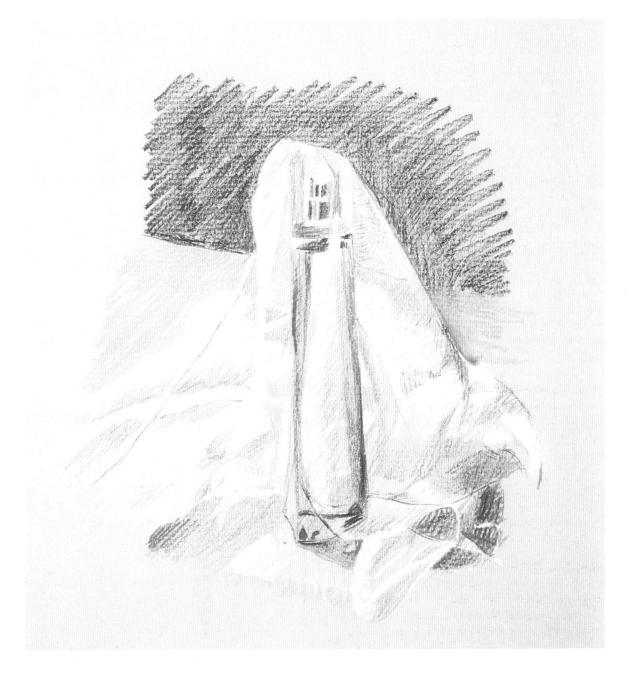

Can you give me any tips for drawing a flame?

Replicating the flame of a candle, a burning torch, a bonfire, or a fire in an open hearth all present particular problems for the artist because, not only is a flame very bright—much more so than the whitest paper—it is also of no fixed shape and does not have clearly defined contours.

The artist has to resort to tricks in order to give a convincing illusion of flame. The techniques used to accentuate brightness are similar, irrespective of the type of flame, and this is also true of the depiction of any light source.

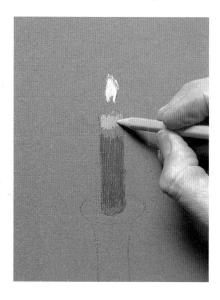

A flame is much more visible against a dim background, so arrange the composition with a dark backdrop behind it. Select a dark tinted paper to further accentuate the flame. This will help to lift the lighter colors. Start by drawing the flame as a quick scribble of yellow. The red wax of this candle takes on a pale luminescence close to the base of the flame. Apply these preliminary layers of color, taking into account that they will be worked over and perfected at a later stage.

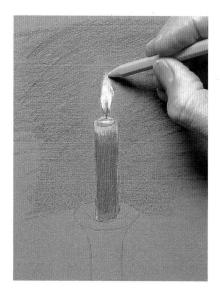

The shape of a candle flame is not difficult to draw, but to make it appear as a light source requires some ingenuity.

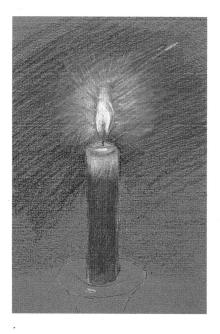

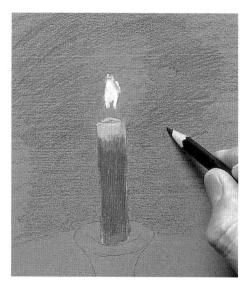

Add the blue base of the flame and the pinkish tip. Draw the dark wick and the pale reflection of the flame in the molten wax just below the wick. Continue to shade in the flame's immediate surroundings using a dark pencil to accentuate its lightness.

In real life, a flame appears to blind out its immediate surroundings with a pale halo, and the same should be true in a drawing. The eye perceives streaks of light radiating from a flame, so mark some of these using a Chinese white pencil. The contrast between the light flame and its halo against the dark background give a good impression of a light source. If the drawing were to be extended down to the tabletop, a flickering shadow of the candlestick and candle could complement the flame.

How can I convey the delicacy of flower petals?

The positions of flowers in relation not only to each other but also to the leaves and stems are characteristic for each type of plant. Accurate observation of these relationships and the angles at which the flowers are held by their stems will, in many cases, be enough to identify the plant, even in a rough sketch lacking detail.

The ability to capture the delicacy of each flower and individual petal requires careful attention to all their subtle curves and folds and the way they overlap. With a degree of shading to reveal their transparency, your drawing will come to life.

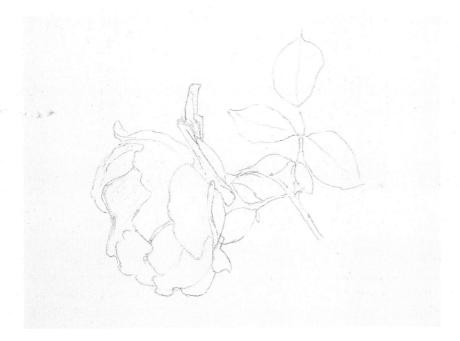

Perhaps the easiest way to start drawing a rose is to plot the shapes and positions of each petal with a contour drawing. Every curve and all the unexpected imperfections, if observed accurately, will help to convey the subtleties of the flower in the final picture. This also applies to every twist and turn of the leaflets, so that a drawing of this particular rose is the outcome.

Using a variety of pinks, ochres, and reds, lightly fill in the colors of the rose. Choose a pale sheet of paper so that its luminosity shines through the petals. Work as fast as you can because, being a living thing, the rose may lift or droop and its petals will unfurl surprisingly quickly.

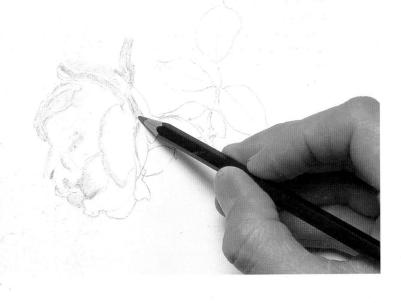

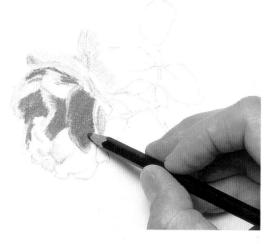

Add shadow to some of the pink petals using a dark purple pencil. Dark blue or dark green can also be used to darken red. Remember: it is usually best to avoid black to darken color because it is overpowering and deadens other colors.

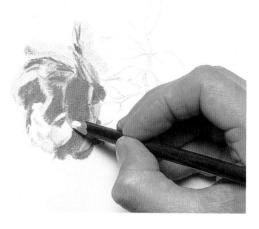

Use Chinese white to burnish some of the reds and to produce very pale delicate pinks for the highlights. Keep looking at the real rose in front of you to ensure that you do not lose the exact shapes of the petals painstakingly drawn at the beginning.

ARTIST'S NOTE

Particularly when brought indoors or put in a new spot, flowers continue to open, lift upward, turn to the light, lose petals, or die. When attempting an accurate, detailed drawing of several flowers together, it is best to complete each one before starting on the next.

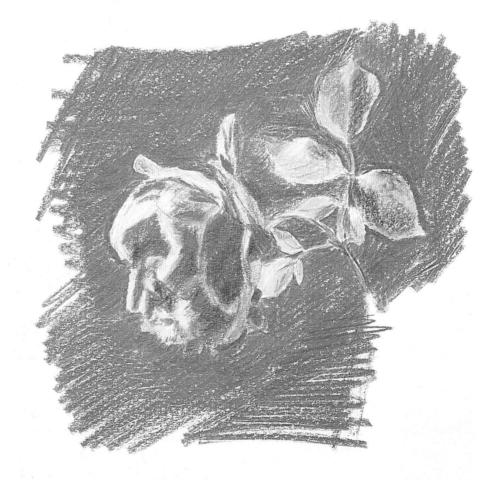

Tone down the background. The real rose was, in fact, seen against a dark wall, and the highlights of the petals stand out better now. However, beware of too much dark background in pencil, as it can become very oppressive.

Below *Anenomes* by Hilary Leigh, drawn with water-soluble pencils on a good-quality watercolor paper, shows how the vibrant colors and forms of flowers can be captured in a drawing.

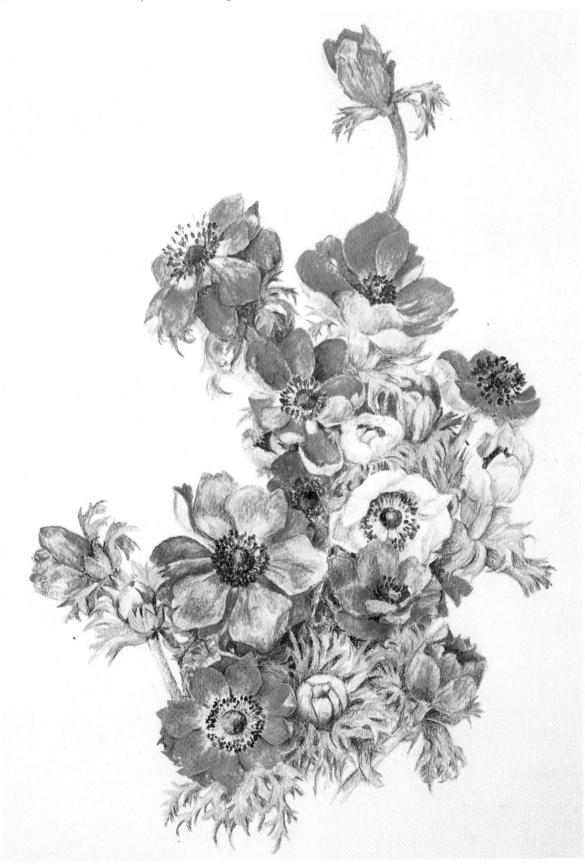

Demonstration: Irises and freesias in a glass vase

The study of flowers in terms of portraying them on paper or canvas is endlessly absorbing and rewarding. Their infinite shapes and often dazzling colors never cease to amaze, once you start to look at them carefully. Cut flowers will probably be placed in a vase or pot of some description, and this can also be exciting to draw. The irises and freesias in this picture were bought from a florist just before starting the drawing. When brought in from the cold, flowers open quite rapidly, so draw each flower to completion before starting the next one.

Once you have decided on the position of the vase and flowers on the paper, mark these lightly on the paper as guidelines. Draw each flower accurately, taking measurements "sight size" and keeping an eye out for the negative shapes between the petals. Color the petals of the irises uniformly in purple, and rub in Chinese white to bring out their color in the lighter areas.

Draw a vertical "plumb line" through what will be the center of the vase.

The left petal of the first iris is positioned slightly to the left of this line. Marks on the paper indicate the positions of the bottom and top of the vase, as well as various petals.

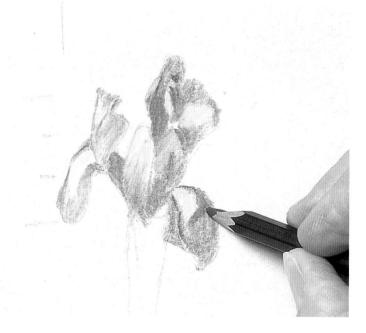

A touch of pale blue gives the characteristic bloom to the petals, while dark blue applied with a fair degree of pressure darkens the purple in the shaded recesses of the flower. Darken the yellow central flash on the petal in shade with ochre.

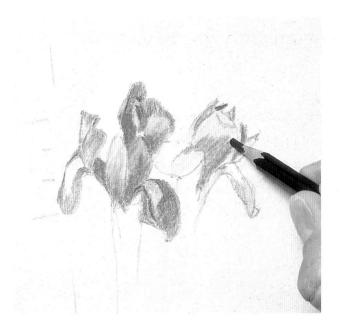

A fascinating feature of the color of this variety of iris is that its flowers appear a vivid blue in daylight, but as soon as they are viewed in artificial light, they appear largely violet. The same is true of a number of other blue flowers, such as cornflowers, hydrangeas, and pansies. The flowers in this still life are illuminated by an ordinary electric lamp to the left of the setup.

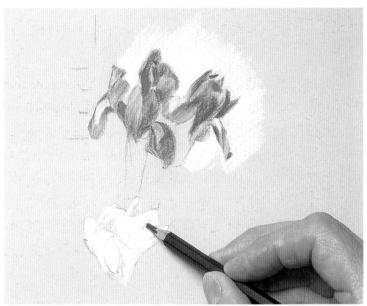

A white flower—or anything else that is white—never appears pure white all over, even though its intrinsic, or so-called local, color is white. Variations in the lighting and reflections from other objects invariably produce a host of blues, purples, and browns. Erase any redundant measurement guidelines, then fill the contours of the white freesia with a uniform white. Apply blue-gray to the darker areas of the petals. Although not intrinsically blue-gray, they take on this color when turned away from the light.

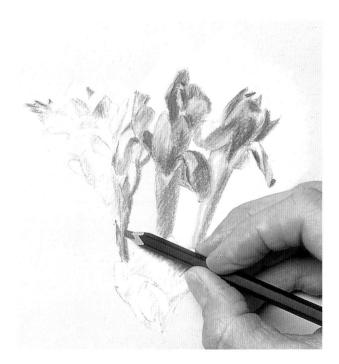

The actual, or local, color of the stems varies from a bluish green to a yellowish green. These also vary according to the light they receive. You will therefore need a number of different pencils, such as this dark blue, to deepen the tone of the shaded side of the stem.

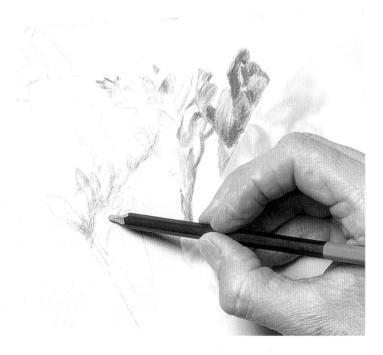

Measure and draw another flower head, as before, using an HB pencil. A softer pencil is inadvisable when white is to be used because it tends to smudge into the white and spoil it. Although mainly white, these freesia petals actually have a flush of yellow on their outer side, which appears ochre when shaded. Use of a sheet of paper to prevent the hand from smudging other parts of the drawing.

The composition is starting to take shape. Insert another freesia to break up the rather dull, upside-down triangle formed by the other flowers. Continually assess your progress, and don't be afraid to make adjustments where you see fit.

ARTIST'S NOTE

All the petals' yellow centers were colored first as a safeguard to prevent purple being drawn there by mistake. Purple is not easily erased, and white or yellow will not mask it sufficiently. It can save a lot of trouble sometimes if you can think in advance in this way.

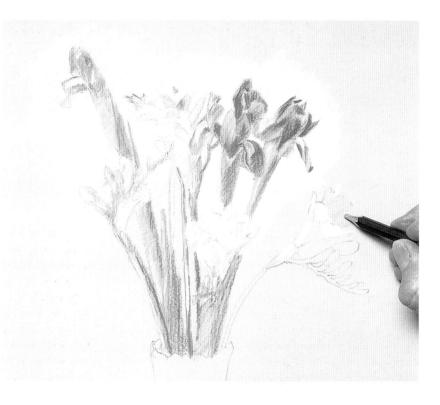

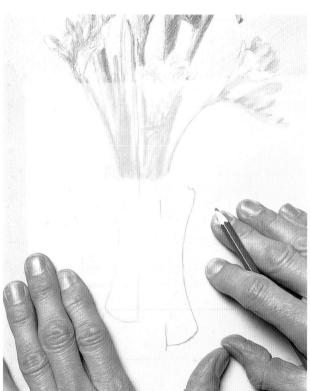

To ensure the vase is absolutely symmetrical, make a tracing of the left side, including the mid-line. Turn the tracing paper over, put it in place, and go over the traced line with a hard pencil to transfer it onto the paper (see page 19). In an accurate study such as this, a poorly drawn vase would simply look wrong. In some pictures, however, even gross inaccuracies can add to the charm of the work.

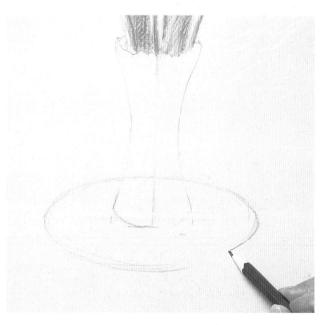

You may encounter some difficulty with the ellipse of the doily. Measure both the vertical and the horizontal diameters with your ruler held at arm's length. Remember that the horizontal one should be more than halfway up the ellipse (see page 44). The rest has to be done by eye.

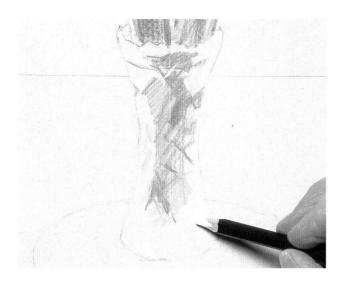

At first glance, the crystal vase looks impossible to draw. Start by drawing the large plain areas and major lines. Here, a large, central pale green area is a starting point, and dark green lines establish some landmarks around which to base the rest of the coloring. Add highlights early on, as these will never be sufficiently bright if drawn over dark pencil work. Look at the actual vase, and see where each bright streak of light is. Is it halfway or a third of the way up? If in doubt, measure it.

The vase casts a shadow to its right, over the doily, that is most pronounced and darkest as a triangle closest to the vase. It is quite easy to fail to notice a shadow, but it is as important as anything else in your drawing, since it anchors the object on its support and helps to define the three-dimensional form of the object. This is a very simple composition. In complete contrast to portrait drawing, where detail is the last thing to include—if at all—here the detail is of paramount importance. It doesn't matter too much if it is slightly wrong, unlike in a portrait, where the slightest error can ruin the likeness.

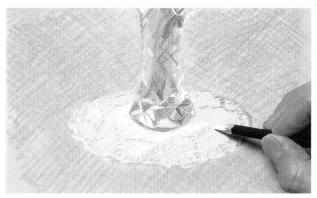

A thick glass vase usually has gray areas at its base, which, in this case, are mostly triangular in shape. The stems do not reach down to the bottom, so there is no green. Tone in the background—in this case the tabletop—and add some of this color to the vase. Now color in the doily using gray, followed by Chinese white. To create the appearance of holes in the doily, add some background color over the white in a pattern similar to that of the doily. You will need to rub more Chinese white over the brightest areas and around the right-hand side of the holes to give them their raised appearance.

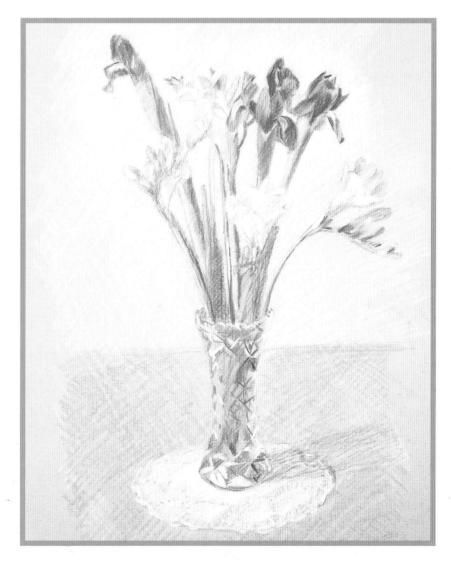

3 Rendering outdoor scenes

Ithough beautifully observed details of hills, fields, and flowers began to appear in religious paintings even before the Renaissance, landscape became accepted as a subject in its own right only in the seventeenth century. Today, landscape is probably the most popular of all subjects to draw, perhaps because of the mistaken belief that it is "easier" than drawing or painting buildings or portraits. While you don't necessarily have to achieve a specific likeness in a landscape, a hurried, "lazy" approach will still give obvious and unsatisfactory results. Try to include every bump, nook, and cranny just as it is, and don't be tempted to make things up. If you don't draw the contour of a hill exactly right it may not matter; but what you do draw must be as interesting and feasible as whatever it is you are replacing.

Outdoor drawing also includes townscapes and seascapes, the latter being particularly demanding of your skills. It requires patient and careful observation to analyze exactly what makes sea look like sea, and therefore to decide how to draw it. Townscapes involve angles, converging straight lines, and vanishing points—a whole new set of disciplines—and understanding the theory will help you create believable drawings.

The weather has to be reckoned with in temperate climates, and even when it's sunny all the time, you have to contend with the relentless movement of shadows throughout the day. Rain usually puts a stop to all activity, but the

reflections on the wet surfaces of roads and paving after rain are interesting to observe and draw. The study of the reflections on rivers and lakes and their variability according to ripple size are an endless source of fascination. Everyday atmospheric phenomena such as haze, mist, and clouds alter the appearance of a landscape and are exciting to draw, especially using colored pencils. Snow is particularly effective if drawn on a dark ground using white and other pale pencils. Dusk and night pictures have to be drawn indoors (simply because you can't see out there in the dark). Indeed, in pitch darkness there is nothing to see, so night pictures rely on lamps, moonlight, or the residual glow of sunset, and they are best tackled with pale colors on a dark ground.

Landscapes and townscapes can be equally effective if drawn solely with contours or if they include shading. Whether you use color or confine yourself to black and white is a matter of personal preference, and how you feel you can best convey the essence of the view in front of you. Color does add an extra dimension to your pictures and would certainly ease the task when tackling snow or sea.

Some outdoor drawings can be described as still lifes: pots, plants, and gardening equipment beside a greenhouse; garage tools, old tires, and exhausts in a mechanic's yard. There is always considerable overlap in the categories to which pictures are assigned.

I have difficulty choosing a composition in a landscape. How should I select the focal point?

Having decided what it is about a landscape that appeals to you, choose a viewpoint that assembles these features in a way that captures the essence of that landscape. A focal point in a drawing aids its composition, since every part of the picture will relate to it. A track disappearing into the distance, a tree on the horizon, or a figure in the foreground are examples of focal points. Strategic positioning of strong shapes can lead the eye around a picture, but balance is important. In the picture on the right, the mass of vertical building is balanced by the horizontal of the bridge.

FOCAL POINTS

Although at first sight this may seem a random scattering of little houses, in fact the focal point is the bell tower of the church in the top left-hand corner. Draw the positions of the main houses, and loosely shade the dark areas of vegetation and shadow.

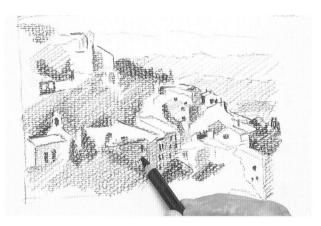

Add more houses to the right, and include eye-catching details such as windows. Increase the spacing between the hatching to create a sense of aerial perspective, as the background hills become paler into the distance.

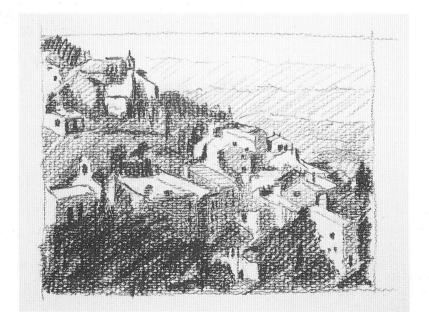

Accentuate the focal point—the bell tower at top left—with dark pencil lines. The rooftops of most of the houses slope up toward it, while the street of houses (middle left), spirals around the hillside, also helping to lead the eye around and up to the focal point. Shade darkly in the foreground to create greater depth.

BALANCED COMPOSITION

Sketch a simple line drawing to form the basis of the composition. This subject is built around strong verticals and horizontals. The tall tower to the left and the pier in the foreground have equal prominence, while perspective leads the eye to the beached boat and the distant bridge and buildings of the city.

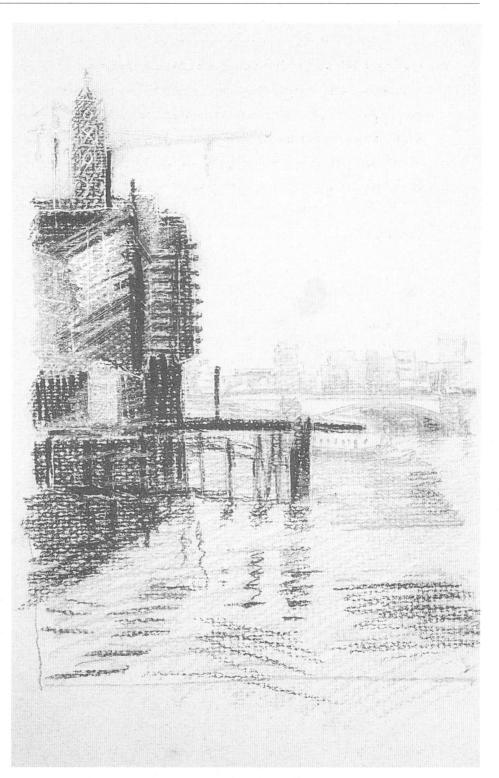

The pier supports and their reflections in the wet mud below form the focal point of the picture. Draw these forcefully at an early stage. In addition to using verticals and horizontals, this composition also relies on triangles. Set up a diagonal tension between the crane and the distant bridge to complete a triangle echoed by the incomplete triangles made by reflections in the mud.

Balance the dark mass of the vertical building on the left with the eye-catching (horizontal) bridge on the right. The horizontal crane gantry echoes this, while everything pivots around the central pier. Give attention to regular patterns and symbols in any composition because they help to draw the eye around the picture.

A

Light—particularly in the blue region of the spectrum—is scattered by the atmosphere, especially if it is a little hazy. Smoke also scatters light and often appears blue—anything seen through smoke will also look blue. Between you and a distant hill, there may be several miles of atmosphere. The farther away the hill is, the bluer and paler it appears, so we can tell how far away different parts of a landscape are by their paleness. This phenomenon is termed *aerial perspective*. On a very clear day with virtually no haze, aerial perspective is weak, and distant hills can appear quite close.

Forested hills at three different distances dominate this scene. First, draw some lines for guidance, and then block in the farthest hillside using pale blue. You may add to this later, but it is difficult to decide on final color until you have covered more of the picture surface.

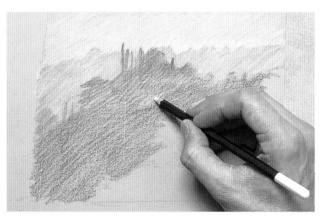

2 Shade the second from farthest hillside using a darker blue. Rub Chinese white to burnish it, which will also make it stand out. Draw the exact shapes of the silhouetted contours carefully—the viewer's attention is drawn to them far more strongly than to the featureless dark valley sides.

The nearest hillside is darker and contains more green, since it is seen through less atmosphere and the light has been less scattered. Apply the green and then hatch over it with dark blue to give a rich deep tone to this close hillside.

Color the tower with ochre to emphasize the blueness of the background hills in this slightly misty, early evening landscape. The same increase in paleness and blueness with distance is commonly seen in any outdoor situation.

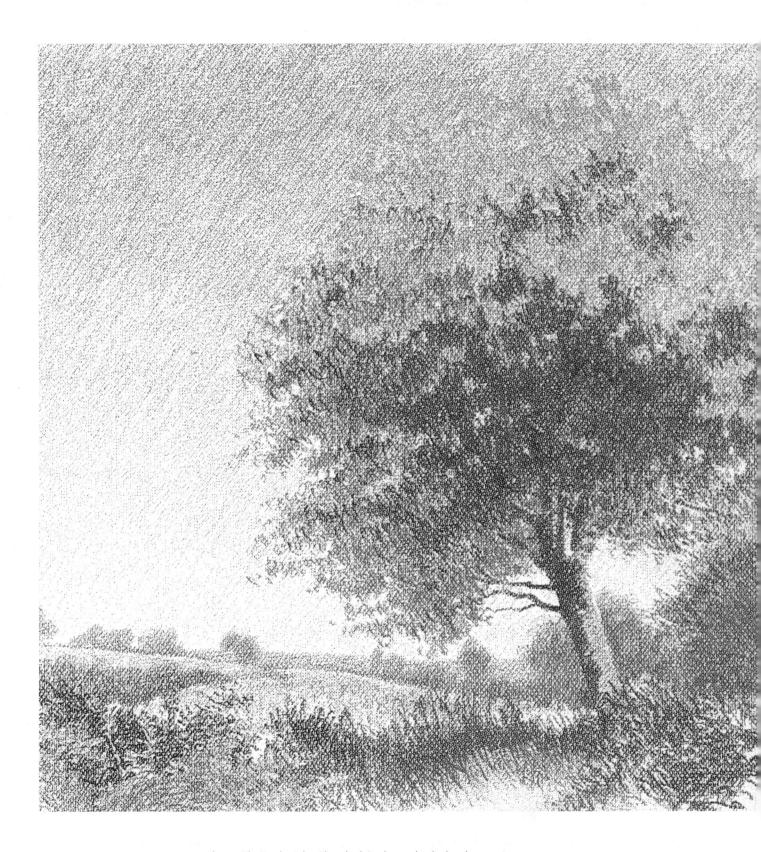

Above *The Tree* by John Chamberlain shows clearly the phenomenon of aerial perspective. Contrast the blueness and paleness of the background with the detail in the foreground of the scene.

How is a sense of depth created in a landscape?

Without either linear or aerial perspective, a landscape is likely to be flat and without depth. This does not necessarily matter since this may be the effect you want to create. However, to feel drawn deep into three-dimensional space in a picture does require the use of illusory techniques on the flat picture plane. The apparent diminishing of size and the increasing paleness with distance, along with the convergence of parallel lines toward a vanishing point all contribute perspective and depth to a picture.

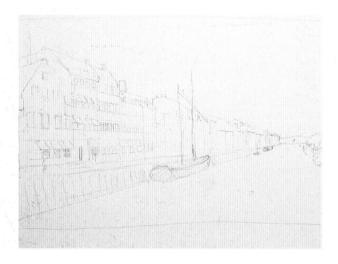

To illustrate both aerial and linear perspective, this straight canal receding a long way into the distance is ideal. Draw the rooftops, windows, doors, and path with the aid of ruled converging lines to the vanishing point.

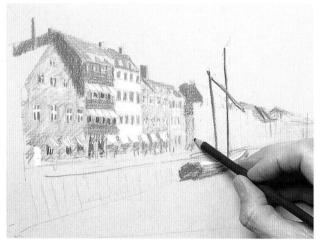

Complete the houses one by one. Work on them further only if they need enhancing in tone at a later stage. Here, a dark blue lays the foundation for the side of a house that lies in shadow.

As they recede into the distance, draw the canal-side buildings with increasing paleness and with less and less detail. This is roughly how we see things in real life. Draw the boats and buildings on the right-hand side in shade. These add more converging lines to the vanishing point and indicate that we are looking at a canal. Strengthen the tone in the foreground, and color the reflections in the water. Rapidly scribble in the sky, making it paler in the distance. Add a yellow tint toward the horizon. Mirror the yellow tints in the distant water, where it reflects this region of sky.

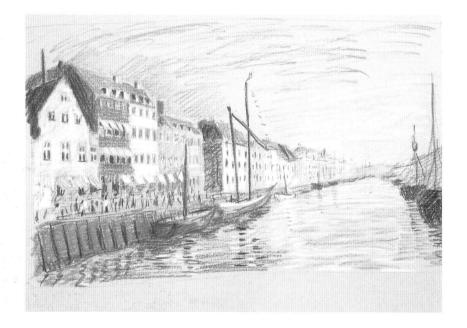

How much detail of trees and plants should I include in a drawing?

In reality, unless you look closely, one does not see the individual leaves on a tree. The farther away the tree is, the less significant each leaf becomes. A tree takes its form mainly from the pattern of shadow and highlights created by whole branches or groups of leaves. Concentrate on these same darks and lights to create the illusion of a tree. You can add a few of the more prominent leaves if you wish. The same technique applies when you draw flowers in a meadow, as shown here, or individual buildings in a distant cityscape.

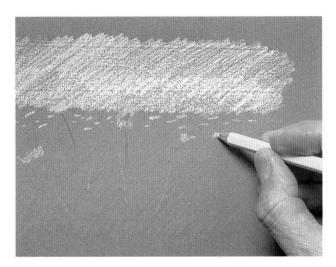

Hatch red over the blue paper to create the overall neutral purple color of the meadow. Add distant yellow flower heads close to the horizon as simple yellow streaks. Place some nearer, larger flowers at the level of the horizon; their stalks indicate that they are actually in the foreground.

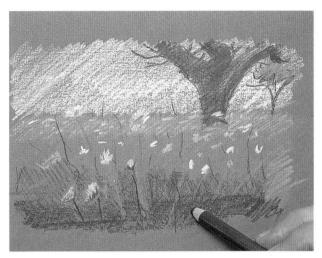

Darken the bases of the plants in the foreground to give depth to the sketch, and include a couple of trees. Show only the closest flowers in any detail, which is slight in a sketch like this.

Draw further hatching around the flowers with extra layers of color to create a more unified whole. If you are in doubt about the amount of detail to include, blur your vision to see the most important aspects of the view in front of you. Remember that detail in this kind of sketch should always come last.

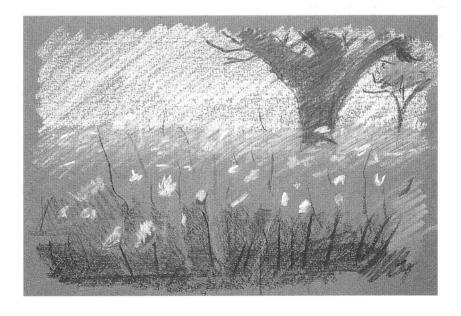

Distant features in my landscape often appear to be too close. How can I correct this?

It is difficult to believe that a distant house or tree takes up so little of one's visual field. Many beginners make these features too large, upsetting the balance of their composition. When you measure with a ruler (see "What is meant by drawing sight size?" page 24), you may be surprised at just how small a house can appear—it may be smaller than a nearby blade of grass. In the same way, fields approaching the horizon take up a tiny amount of space; if you don't measure them (using a ruler or, with experience, by eye), you may well draw these too big.

The barn in the top-left corner is, in reality, about the same length as the whole farm in the foreground. However, seen from a distance, it is much smaller. As you sketch, measure each subject in your composition. This will help you keep everything in balance.

The large expanse of field separates the near farm buildings and the house and trees at the top of the hill in the distance, so there are no converging lines or other features to help with the perspective. Therefore, measure the relative distances in the scence carefully.

As you sit before the scene in front of you, hold your pencil or ruler at arm's length to make simple comparisons of distances. The length of the barn is the same as the width of the road in the foreground, so draw them the same width.

Compare the sizes of the trees before you draw them. Those in the foreground stand more than a third of the picture height. Those at the top of the hill are merely one-twentieth of the picture height, while the isolated trees on the farther hill, to the right, are half that size.

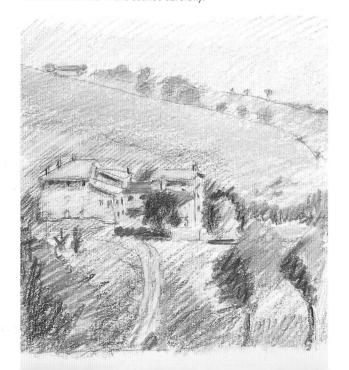

Below *Copping Hall* by John Townend provides a good example of a correctly proportioned landscape; there is a balance between the foreground tree, the field and the correctly proportioned house beyond, and the fields and trees in the distance.

Demonstration: Street scene, south of France

Picturesque street scenes in villages such as Lacoste, in Provence, are always a favorite subject for artists. One of the advantages of drawing in a Mediterranean climate is that the conditions remain more or less constant from hour to hour and day to day, so you can take as long as you like on a picture. However, you should remember that the sun and its shadows move throughout the day. This subject will call upon your skills in composition, measuring, perspective, and color mixing. This scene would also be just as rewarding to draw in black and white.

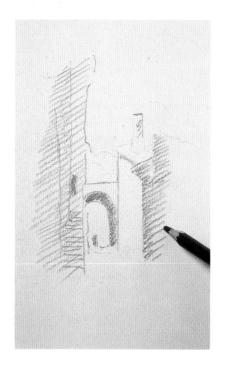

The little archway at the end of this street is the focal point of the picture. Make a rough frame with your hands, and look at the subject through it to decide on the approximate composition. Draw the subject "sight size" (see page 24), so that every measurement made at arm's length is the same as the measurement on the paper. Draw around the focal point and shade certain areas for your reference so that it is obvious which part is which. Simple loose hatching is all that is required.

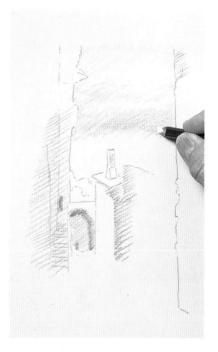

Block in preliminary color in the sky and on the distant hills. Add some Chinese white to make them paler. Cover large uniform areas quickly to gain a feeling of how the picture is progressing.

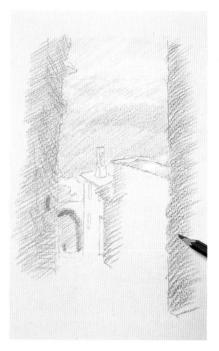

This narrow street is bordered by tall houses on either side, giving strong, dark verticals that contrast with the sunlit parts of the buildings. Use dark blue for undershading, bearing in mind that you will hatch grays and browns over this later. Now that you have established the basic framework of the composition, focus the attention on some of the detail. Draw the bright sunlit roof with Chinese white first, then tint it with orange. This gives a paler final color than the nearer roof, drawn in orange first and then in Chinese white.

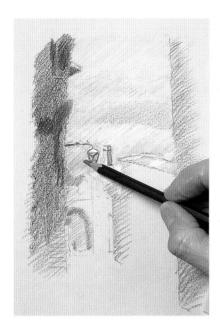

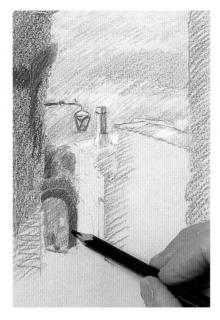

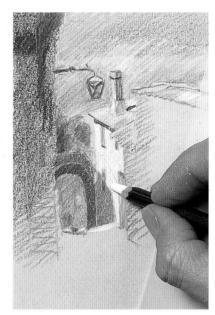

Make the distant hills increasingly blue, partly to increase the density of pigment on the paper and partly to enhance the impression of distance. Hills do look blue in the distance, owing to the scattering of blue light by the atmosphere, especially if it is a hazy day. This phenomenon is known as aerial perspective (see page 68).

The little hanging lamp serves as an important symbol, with its symmetrical shape and wrought iron work. Any regular shape can be regarded as a symbol and will always arrest the eye and therefore serve as a useful pictorial tool. The archway and the rectangular chimney are both symbols in this sense.

It is always very satisfying to add the highlights to any picture. The right-hand walls receive the full force of the summer sun. Color these with a bright off-white. To prevent smudging your drawing, use a clean sheet of paper to protect it from your hand.

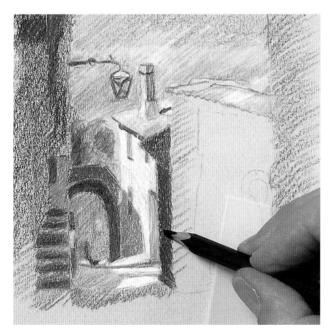

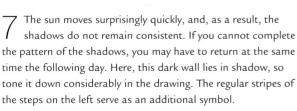

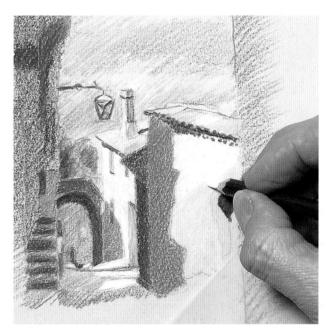

Accurately draw the outline of the large vertical shadow on this wall. Pay attention to such shapes—do not create them from your imagination; the real thing is likely to be much more interesting. Shade the sunlit part of this wall with ochre, and then rub white over it.

While mostly in shade, the road is dappled with patches of sunlight, which add greatly to the charm of the setting. Observe their shapes, so that the uneven road surface becomes apparent. Color the shapes of the shadows to create the impression of the dip in the road.

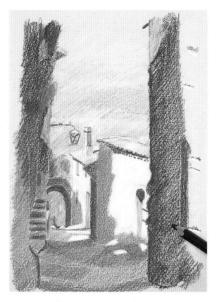

The whole street scene is enclosed, or framed, by the tall dark walls in the foreground. By composing the picture this way, although the viewer is made to feel apart from the scene, he or she also feels privileged to obtain this glimpse.

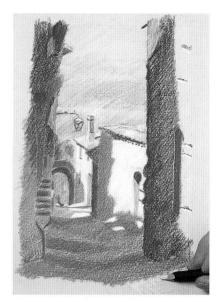

The extreme foreground contains a patch of sunlight. This appears much bigger than those down the street. Sunlight also falls on the right-hand wall, further enhancing the frame effect of the tall dark walls and the shadowed road between them. Add these light areas.

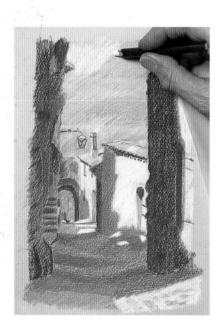

Now pay attention to the sky. Give it a coat of white over the existing violet and blue hatching. The sky on this sunny but slightly hazy day appears very pale, especially toward the horizon. The pale sky at the top echoes the pale sunlit road at the bottom, as the rest of the picture is enclosed between them.

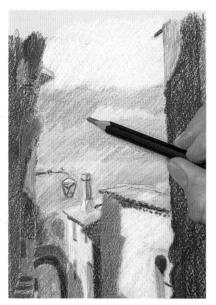

To increase the contrast with the newly lightened sky, tone down the distant mountains with more blue. One of the exciting properties of colored pencils is that you can add layer upon layer, subtly changing the effect each time to give a final rich overall color.

Now burnish the blue of the distant mountains with Chinese white to make them seem even more distant. In addition to the effect of aerial perspective, buildings appear smaller the farther away they are. No converging lines can be drawn to a vanishing point here, because none of the features are parallel to each other.

Reinforce details beyond the archway because this is the focal point of the picture. Placing the archway low emphasizes the road's steep gradient and enables the mountains and sky to be included. Placing the archway to the left leads to more of the sunlit wall on the right being visible.

Complete the picture with continued work on the road and elsewhere. It is not easy to know when to stop, but it is better not to overwork a drawing. If you reach the point of not knowing what to do next, you may well have gone too far already.

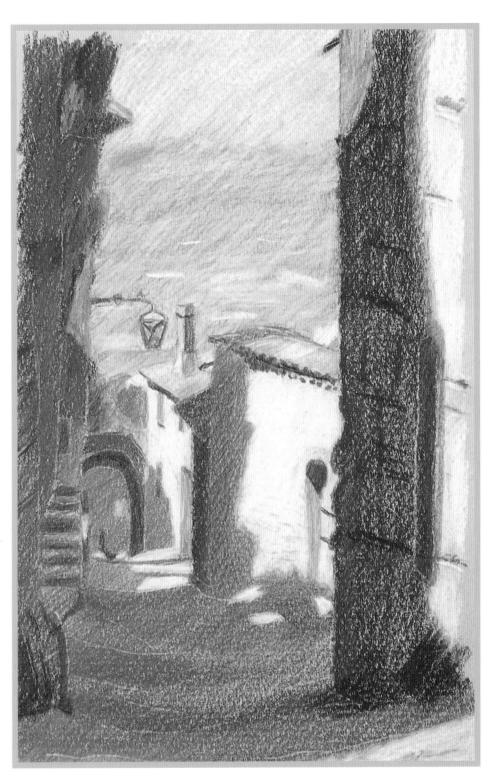

The eye-catching shapes of the hanging lamp, chimney, patches of sunlight on the ground, and arched doorway all lead the eye to the focal point of the drawing: the little archway at the end of the street. Balance the dark wall on the left with the large expanse of dark wall on the right. The narrow, enclosed street contrasts with the vast open space to the mountains beyond, avoiding any possibility of claustrophobia.

Where should I place my figures in a landscape?

A

If you are standing on flat ground, the heads of every other standing person, however far away, will appear at the height of the horizon. Such a situation may occur in a town square or road, on a beach, or on a playing field. Similarly, if you are seated, the heads of other seated people will coincide again with the horizon.

Remember that this rule applies only if the ground is flat; on rising or falling ground, you will have to measure the positions of people carefully.

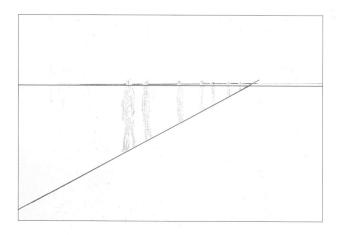

In this imaginary sketch, each person is of the same height. All their heads appear on the horizon, as this is also the height of the onlooker's head. Their feet rise up the picture plane to meet the horizon at a vanishing point. The farther away a person is, the closer his or her feet are to the horizon. So, even without looking at a real person or measuring anything, you can place figures correctly.

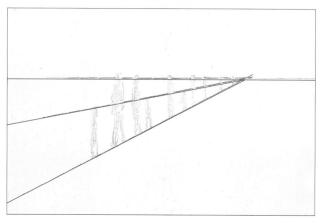

People taller than you will appear a little higher, and those shorter, lower. The heads of the three children are joined by a new converging line, lower than the horizon but still ending at the vanishing point.

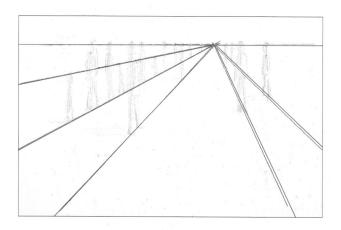

Regardless of a person's height, it is the position of the feet that tells you how far away they are.

As long as another person's head is on the same level as yours, it will appear on the horizon of a flat landscape. Here, the artist's head is crossed by the horizon. This is a useful tip if you want to make it clear that you are at the same height as your subject.

Above The Bowling Green by Neville Graham is interesting in that the viewpoint of the artist is clearly very low. Notice, though, that the heights of the figures still decline into the distance, down to the eye line, on a level with the artist's gaze.

How can I draw clouds convincingly?

Although no two clouds are alike, they all fall into a number of well-categorized forms. If you know what to look for, you are more likely to identify the essential features of a particular cloud. You will know what features are important to draw, and which can be drawn loosely or left out altogether. The illustrations below show a few of the cloud types commonly seen. In general, avoid hard contours, except perhaps when a bright white cumulus is against a dark blue sky. Compare the darks and lights of the clouds with those of the landscape so that the tonal contrasts are consistent throughout the drawing.

DRAWING A CLOUD

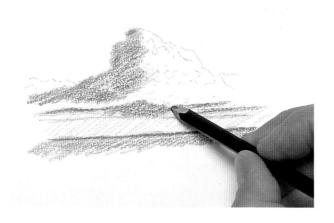

A large distant cumulus may tower to an immense height and appears to grow slowly, giving you ample time to draw it on the spot. Establish the darkest tones first with a blue-gray pencil.

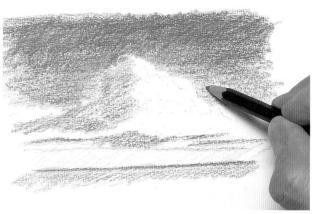

A blue sky usually lightens and often becomes yellowish toward the horizon. Draw the highest part of the sky with a darker blue pencil and below it with a paler blue. Stop coloring at the cloud's edge, although beware of too sharp a contour in case the cloudlike quality of your drawing is lost.

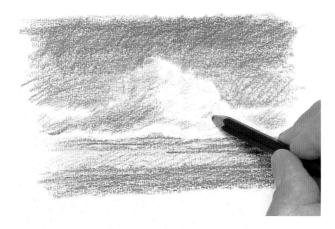

3 Lightly add dark shadows within the fluffy white cloud in blue-gray. The cloud's base is flat and, since it receives little light, appears very dark. The sky below it is dark too, perhaps filled with rain.

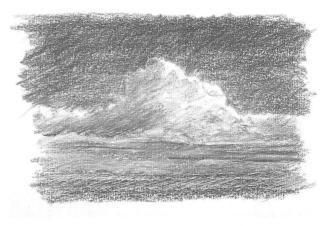

Burnish much of the cloud and some of the sky with Chinese white to smooth out the pencil work. Here, the white of the sunlit part of the cloud is much paler than the blue sky, while the tone of the shaded left-hand side is similar in tone to the blue sky. Look carefully for such tonal relationships when drawing clouds.

CLOUDS IN PERSPECTIVE

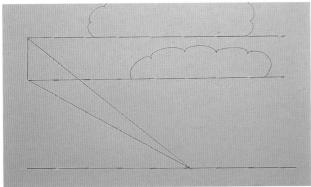

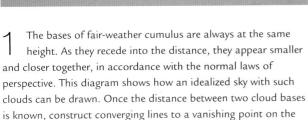

Now draw vertical lines as shown, in order to find the horizontal position of the next cloud base. This is assuming the clouds are all the same distance apart. In real life, of course, they will be a randomly scattered. Nevertheless, the exercise is a good way to learn about cloud perspective.

When drawing real clouds on location, it is not realistic to use converging lines and vanishing points. Bearing in mind the theory, it is easiest to measure the distance of each cloud base from the horizon. Measure their horizontal lengths as well. Do all this as quickly as possible.

horizon.

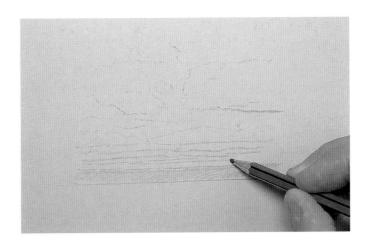

Choose a mid-tone paper for this drawing, so that it is easy to apply both dark tones and light tones. Loosely shade in the lower, darker parts of each cloud; then use Chinese white to produce brilliant highlights for the sunlit parts. When the wind is strong and clouds are moving quickly, it is better to complete each one while it is still in front of you. If you return to an uncompleted cloud, only to find your subject has blown away, you will be forced to invent its color and tonal distribution, inevitably producing an unconvincing result.

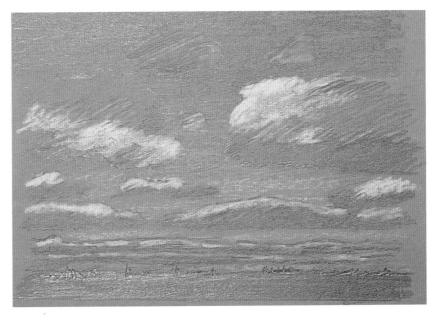

Low stratus cloud can appear dramatic or ominous.

Choose a low position for the horizon and harbor so that the cloud-packed sky is the dominant feature of the drawing.

Measure the heights above the horizon of the darkest underside regions of the cloud mass, and draw these with a dark gray pencil.

Beyond this thick mass of cloud is a clearer region where a little sunlight is filtering through, giving a yellowish tinge. This is essentially a monochrome drawing, but the addition of yellow will enhance the overall effect of the final picture.

Shade the cloud mass to increase its uniformity and make it appear like more of a ceiling. Add a few boat masts to provide focal points and establish the scale of the drawing. Shade the water, but only a little, so that it is still paler than the dark clouds. It is largely reflecting the distant brighter sky.

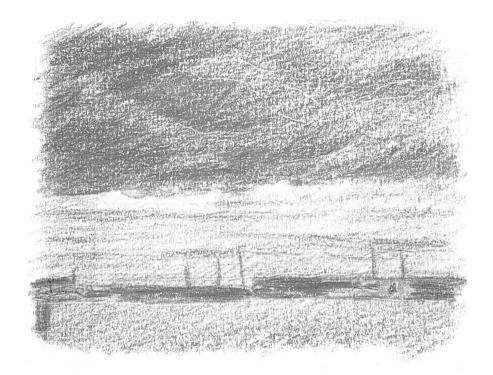

ARTIST'S NOTE

We take the color of sky very much for granted. We are so used to its color gradations down to the horizon that we don't notice what is there. Try looking at the sky upside down. You will be amazed by the colors you now see—purples, pinks, and browns that you perhaps never realized were there.

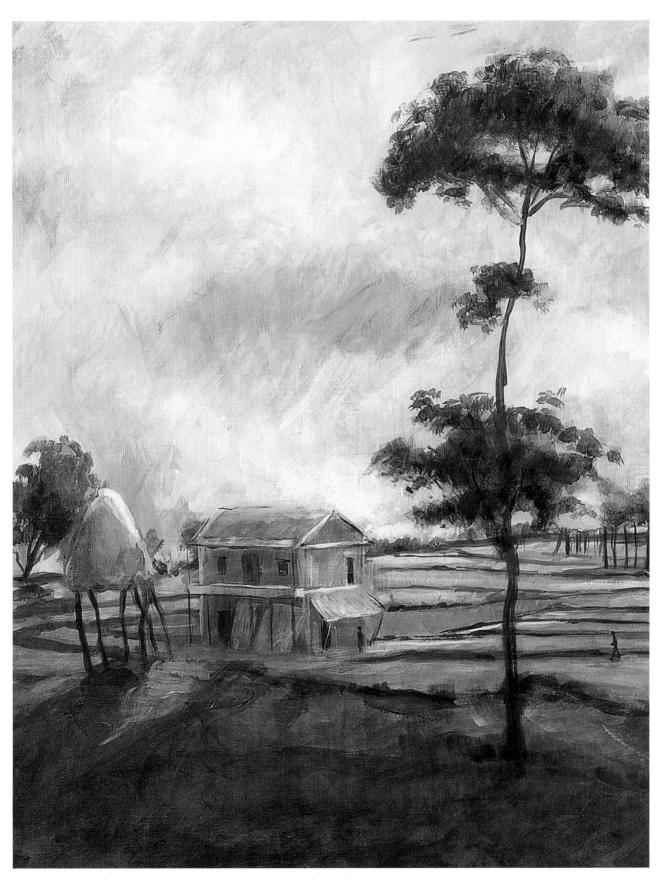

Above *Nepalese landscape* by Paul Collicutt shows how crosshatching layers of color over one another can create rich and vivid variations in flat areas, such as sky and background shapes.

What are some guidelines for drawing reflections on water?

Perfectly smooth water, such as you might see on a lake on a windless day, has glasslike properties. It will reflect anything beyond it—trees, mountains, or clouds in the sky. Close up, though, as you look down into this still water, refraction begins to dominate over reflection and you can see down toward the dark bottom of the lake. In general, the nearer the water is to you, the darker it appears. A little breeze will stir up the water into ripples. Ripples form a complex, ever-changing pattern on the water and can present a daunting prospect for anyone wanting to draw them. However, with a little patience you will find they are not as difficult as you may think.

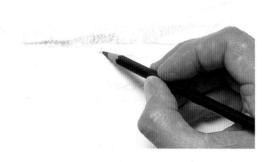

Use a purple pencil as the preliminary color for the leafless trees across the lake. Their reflections are the same color, since reflections on distant, still water are virtually identical to the object reflected. Add some pale blue later, and burnish the reflections with white.

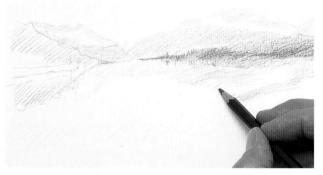

Draw the pale-blue reflections of the snow-covered mountains. The reflection will not be an exact mirror image; what you see in the water is the view of the mountain from that point on the water's surface, while the mountain itself is viewed directly from where you are standing.

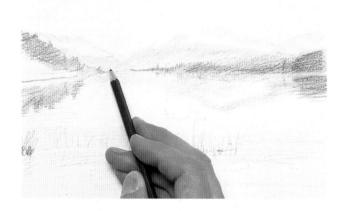

Becho the toning of the sky in the water. The bulk of the water simply reflects the pale sky. This is why large expanses of smooth water appear very light. When the sky is blue, the water also appears blue.

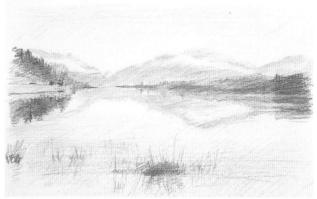

The still water and the absence of loud colors and harsh shapes convey a feeling of peace and tranquility. Totally reflective water such as this will occur only in conditions with no breeze, so that anything associated with wind, such as waving flags or billowing sails, would be out of place.

REFLECTIONS OF SAIL

On close inspection, each ripple contains up to three main colors: the dark depths below the surface, the color of features low on the horizon, and the color of the sky. In front of the boat, the steep part of each ripple appears dark, while the top of the ripple reflects the sail, giving an alternating dark and light pattern.

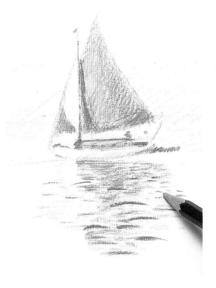

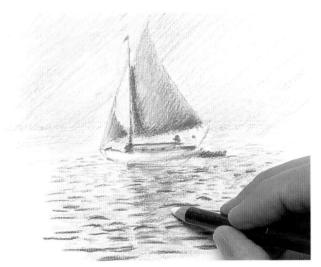

Begin the sail's reflection with loose strokes of the same color as the sail. The water immediately below the boat reflects little or no sky at this point, since the sail towers above it; the reflection is largely that of the brown sail.

The ripples farther away from the sail reflect more sky, giving broader horizontal streaks of light. Draw these in light violet. Also, looking from a higher angle, you can see into the troughs of the closer ripples, so streaks of the darkness beneath the water are visible. Draw these in dark blue and purple.

In general, draw the colored streaks of ripples loosely, but look at their average horizontal length and width-they will become smaller with increasing distance. Note how large the closest ripples are; some of them are half the length of the boat. Burnish them with Chinese white to smooth out the pencil marks and bring out their colors more strongly. Burnishing also helps to unify all the ripples and show that they belong to one sheet of water. The area of water beyond the boat is too far away to see individual ripples, so simply tone it in pale blue and violet. This boat is sailing in a light breeze, enough to produce ripples on the water. Its reflection is a fragmented mirror image, which, if drawn faithfully, will give the desired impression. If you were to copy each reflection from a photograph, your picture would look like just that—a copy of a photograph. Real moving water does not appear as it does in a photograph; it is constantly shimmering and flickering before your eyes.

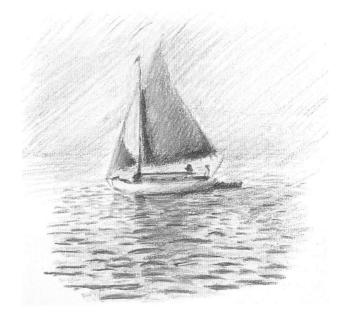

How can I make a surface look wet?

A quick glance out of the window will tell you whether the ground is wet or not. How can one know this so quickly by sight alone? Experience tells us that damp surfaces are darker than usual and that very wet ones can be highly reflective. This is particularly evident on roads and sidewalks—it is not always easy to see if trees or grass are wet. Limestone or concrete paving, for example, scatters light quite efficiently, giving a pale appearance. Once covered with a layer of water, light reflects as if on the surface of a lake. The wetter the surface, the stronger the reflections.

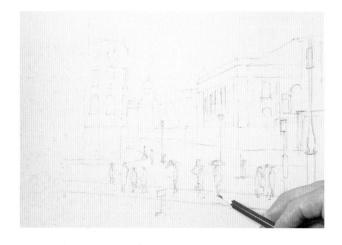

Your preliminary drawing should just be a basic sketch of the buildings, road, and people. Draw in some umbrellas to reinforce the impression of a rainy day.

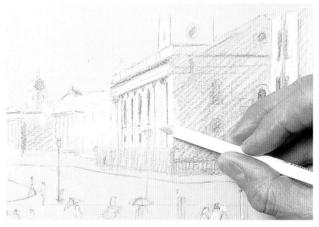

Although it is raining, strong light is coming from the left where the sky is brighter. Any parts of buildings facing left are therefore particularly well lit. Lighten them with Chinese white.

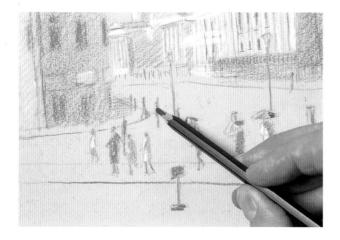

The building on the left is poorly lit and relatively dark, but it contrasts well with the paler areas and gives obvious reflections. Work some more detail into the figures. This will give more opportunity to display reflections in the wet sidewalk, strengthening the illusion of wetness.

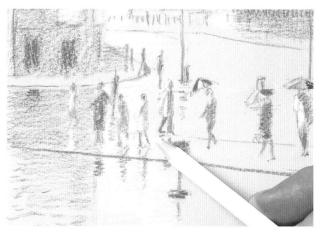

Using a white pencil, gently shade in the reflection of the pale building onto the road surface. The juxtaposition of this and the reflection of the dark building next to it gives a strong indication of how wet the ground is.

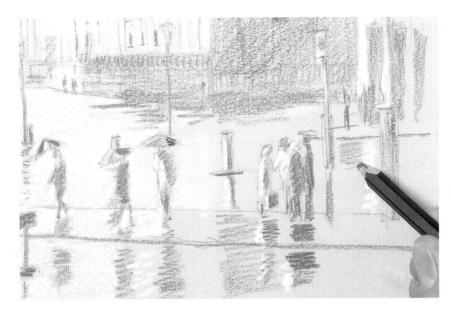

Add the reflections of the people, but do not draw them in as perfect mirror images or it will appear as if they are standing on glass. The zigzag or broken reflections of the people and the street lamps result from the unevenness of the ground and its patchy wetness.

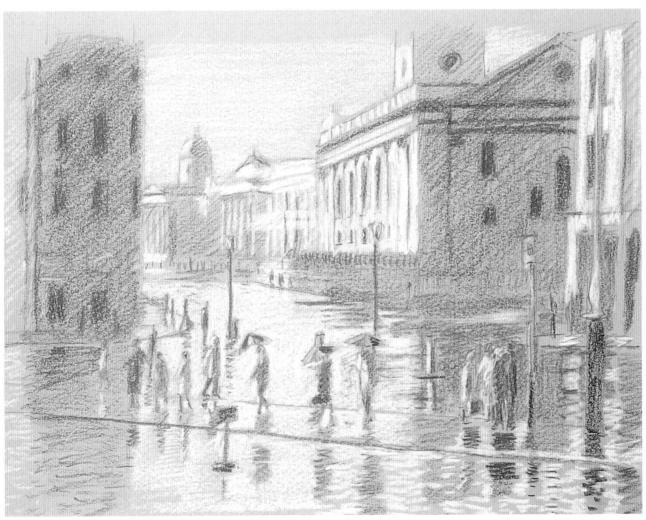

The more things there are in a picture of a wet scene, the more numerous the reflections, and the wetter it looks. If there were nothing reflected except perhaps a uniform pale sky, then the visual clues necessary to tell us that the ground is wet would be lacking.

How can I depict moving water convincingly?

A waterfall, rapids, or simply water coming out of a faucet involve rapidly moving water. In these cases the water is a continuous flow, creating a fairly consistent pattern of lights and darks. If you draw these light and dark areas in the right positions, you should achieve the desired effect. Your drawing will be more dynamic if your pencil strokes reflect the power of the water. They do not have to be in the same direction as the water flow, but keep them vigorous.

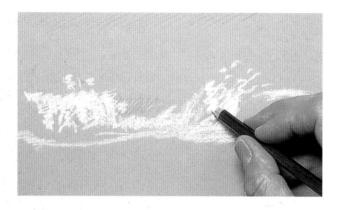

Breakers crashing on the sea shore present particular problems to the artist. Decide which point of the breaking wave you want to depict. Watch for the appearance of a new wave at your chosen point. Remember each time what you have just seen, and draw it quickly. Draw the crashing breaker using vigorous strokes on tinted paper so that the white of the crests stand out.

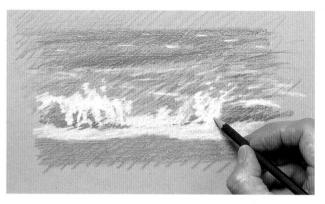

In a rough sea the dominant effect is of waves and the foam of breaking waves. Small ripples are of little importance and are generally unseen. Use dark blue for the deepest shadows under the breakers and a light violet for paler shading, as well as for the foam deposited on the sand. Use some ochre for the churned up water as it contains sand, which gives it a brown tint.

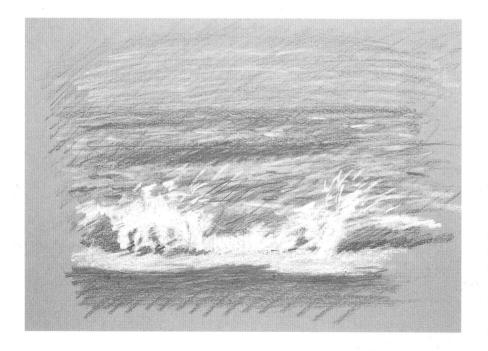

Use white streaks in the sea to depict breaking waves or "white horses"; these become larger the closer they are to the shore. Draw the large wave approaching the shore unexpectedly high up in the picture to allow for perspective. Note that the wet sand is darker than the nearer, drier sand. Scribble in the sky vigorously, in keeping with this stormy scene.

How can I draw outside at night?

Nighttime pictures usually include some form of artificial light—otherwise there will be little to draw. At dusk, the residual glow of daylight silhouettes roofs, chimneys, and treetops.

The immediate problem is that there is not enough light to see what you are drawing, and if you take a light, you can often no longer see your subject without it being radically altered. Therefore, this is necessarily a studio-based exercise and relies on your memory and, perhaps, written notes. However, preliminary drawing can be done in the daytime.

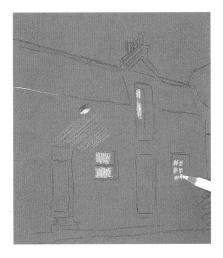

At night, everything is dark except the features you can actually see. Choose a dark blue ground so that you can add both light and dark tones. Use white to represent light from the windows. The drawing instantly becomes a nighttime scene.

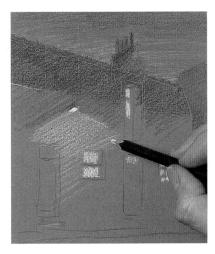

The wall-mounted lamp casts light onto the wall. Hatch this lightly in yellow. Press lightly on the pencil so that the density of pigment deposited on the paper is less than that of the light coming from the windows. There is a little glow left in the evening sky. Contrast this with the darkened roof and chimney.

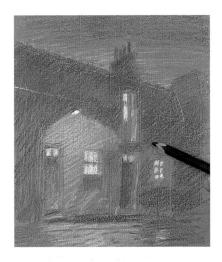

The wall lamp throws light onto the road below. To give a wet appearance to the road, show the extra light reflected from the windows. The sky has the appearance of being clear after earlier rainfall. Deepen the dark tones more to accentuate the nighttime atmosphere. Use a black pencil here, though this is a color to use with caution.

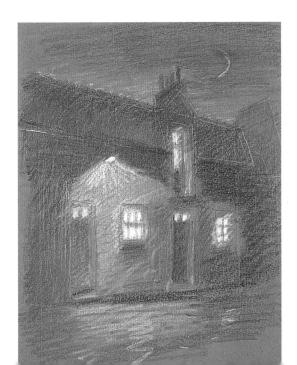

Add a new moon as a single crescent of Chinese white. Draw streaks of white emanating from the wall lamp. These lighten the tone of the wall immediately beneath it, so that this region becomes the main focus of attention. Always take care to stop before you overwork your picture.

ARTIST'S NOTE

It can be exciting to draw at dusk, preferably on a warm summer's evening, until it is too dark to see what you are doing. The scene before you changes by the minute so do a number of quick sketches, keeping your eyes mainly on your subject.

What do I need to know to draw snow?

Fallen snow—like white paper, cotton wool, or the foam of a breaking wave—scatters whatever light falls on it in all directions. In sunlight, it appears very bright white from wherever you look. In cloudless conditions, any shadows cast on the snow are illuminated solely by the blue sky—so they appear blue. In overcast conditions, when the sky is white, snow still looks white, but the shadows are less blue, containing elements of brown, purple, and other tints. People contrast strikingly against snow, a favorite subject of artists, from Bruegel and Avercamp to the Impressionists.

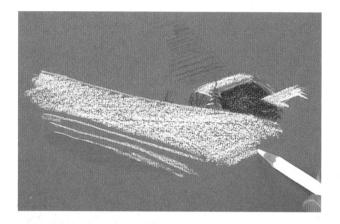

It can be helpful to draw a snow scene on dark paper since all marks made with a white pencil will instantly represent snow. On white paper, you need to tone down everything that is not snow, a much more difficult task.

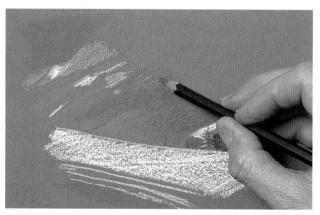

Whole snow-covered mountain slopes in shadow will appear blue, being lit by the blue sky. In fact, the blue ground of this paper ensures that everything appears as shadow until stated otherwise. Lighten the tone of the slope with a pale blue pencil.

ARTIST'S NOTE

It is possible to sit out in the snow for up to two hours provided you are warmly dressed. Artists dedicated to working out of doors have been known to stuff hot water bottles inside their clothing and wear rubber gloves to keep them warm.

Directly opposite a low sun, a cloudless sky often has a violet or purple tinge, and this may be reflected by snow-covered peaks such as this one. Sometimes it can be difficult to assess a color accurately. Try shifting your gaze elsewhere by looking above, below, and to the side of your subject. You may find you see the color better while it is off-center.

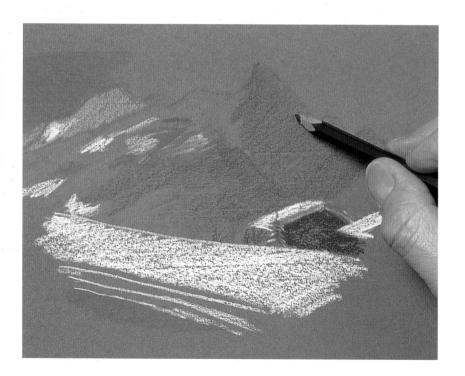

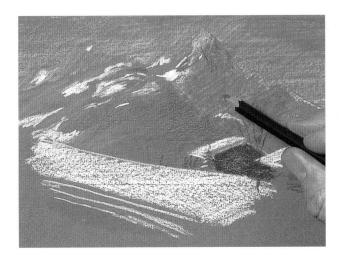

Hatch white over the purple mountainside to lighten it. Now rub blue lightly over this to create aerial perspective and convey a greater distance. Color the sky blue, and hatch over it with white.

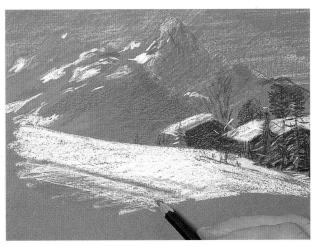

Although the long shadows on the snow in the foreground automatically arise from the blue of the paper, add some blue pencil to supplement this. This makes the shadows look more intentional. Include more snow-covered chalets and trees. Use white pencil for sunlit snow on the branches and pale blue for snow in shadow.

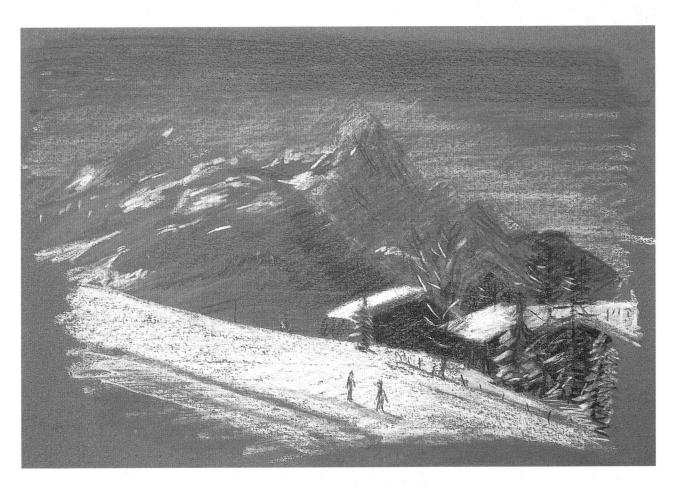

A landscape is often enhanced by the addition of a few figures. Place them low in the picture to emphasize the enormity of the snow-covered slope and the mountains beyond. These two figures also aid in the composition, in that they provide a close focal point while echoing the mountain peak directly behind them.

Demonstration: Waves breaking against rocks

Large waves crashing into rocks are spectacular to watch but pose practical difficulties if you want to draw them. For a start, it is likely to be very windy and cold, so you will have to work quickly. You must also make sure that your drawing is not in danger of being splashed. This rocky shoreline is in the Scilly Isles, England, but you can find similar coasts in many places around the world. The sky is filled with

racing clouds and the sea is rough. A seascape can undergo radical transformations from day to day, so don't expect to be able to continue your drawing on another day.

Make a few simple measurements to establish the positions of the major rocks in relation to the hills of the distant coastline. Decide on the extent of the landscape you wish to draw, and choose a sheet of paper large enough to accommodate it.

Each wave splash is different, and the biggest ones may not come frequently. You have to watch intently and remember what you see, quickly draw it, and wait for the next wave. Draw the bulk of the splash in white, then tone it down with light violet to portray the deeper recesses of the foam and spray. The particular conditions of the sky give the shaded spray its color. Sometimes the spray appears more blue or brown. Look critically to see the exact color in front of you—don't rely on preconceived ideas.

A Indicate the positions of the most dominant clouds in purple, blue, and white. Measure their lengths and height above the horizon accurately. To get them wrong—and this applies to all seascapes and landscapes—destroys the scale of the picture and the feeling of space.

In general, crosshatching using two or more colors is more effective than using one color alone. Lay some blue over the patch of sea in the top-left corner, which has already had white laid on top of violet. Burnish the sky, drawn in purple, blue, and violet, with Chinese white.

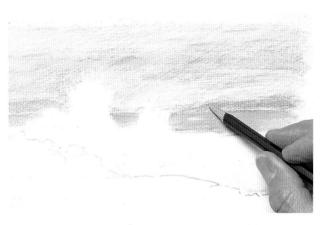

Through a clear atmosphere, distant hills retain much of their color. In this picture, despite the rough sea, the air is relatively haze-free, and the hills appear green with little of the blueness associated with aerial perspective.

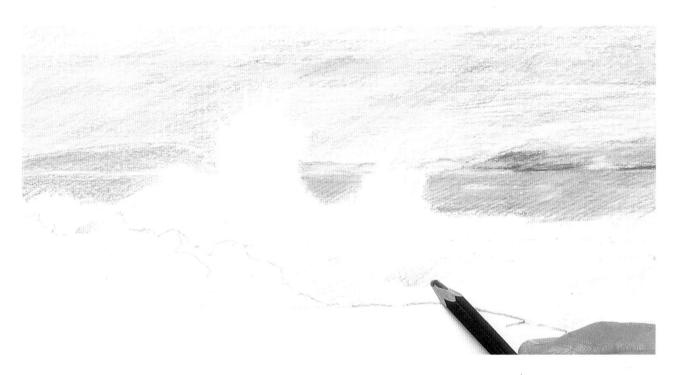

Darken the deeper regions of the splash still further, this time with dark blue. Whereas snow is made up of tiny ice crystals, spray consists of tiny water droplets, but both scatter white light just as efficiently, producing their intense white appearance. The splash also contains foam, which is made of minute air-filled bubbles. These also scatter light, giving the same whiteness.

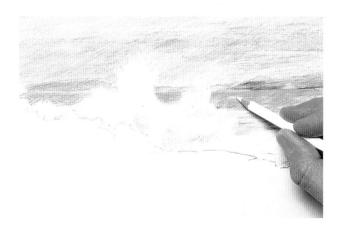

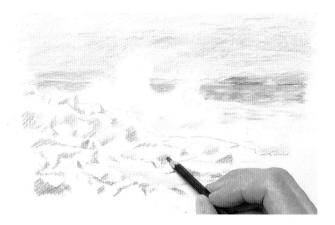

The foreground is always more difficult to draw, because not

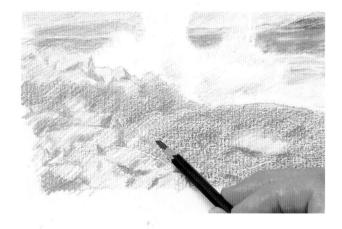

only does it take up half the picture space, but the detail you can see so close up is quite daunting. This assortment of rocks and boulders presents a complex pattern of lights and darks.

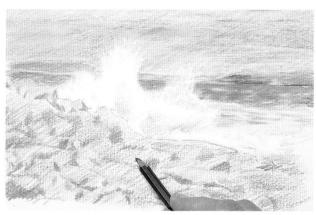

Spend time looking at the shapes and sizes of each rock face and the dark spaces between them. Start with the largest shapes, and plot their positions accurately on your drawing. As a general rule, the resolution throughout a drawing should be fairly consistent. The amount you can see with your eyes half closed is what you should concentrate on at first. You can add more detail later if necessary. Block in all the dark patches of shadow first and then the lighter patches. At this stage, the exact colors don't matter too much, since you will temper them with crosshatching with other colors later on. Hatch on brown with large sweeps of the pencil. This tones down all the rocks, which are much darker than the sea and sky.

Add some dark blue crosshatching to the brown to further darken the rocks. Keep going with the foreground—to skimp on it gives the impression that the artist is lazy and not interested in it. Or it might suggest to the viewer that the artist has given up because it was too difficult.

Burnish the purple on the lightest rock faces with Chinese white. Try looking back and forth from picture to subject, perhaps with half-closed eyes, and spot the difference. You will quickly see whether your rocks are dark enough.

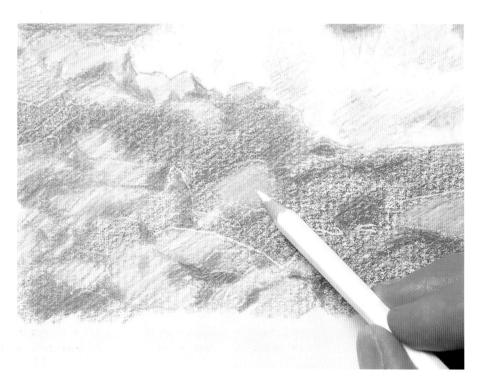

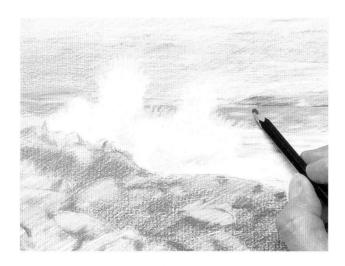

12 Deepen the tone of the sea with blue-gray. During the final stages, it is important to reassess the tonal relationships between the main areas. Add some more detail if you wish.

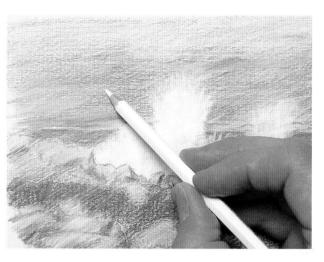

13 If the lower sky is too pale and blue for the stormy scene, hatch over it with gray. If you are drawing a monochrome picture, ignore color and continually assess the tone. Burnish white over the lower sky so that you are adding a fifth color to the four already there. Drawing in this way, layer upon layer, enables a picture to evolve gradually until you have captured the essence of your subject.

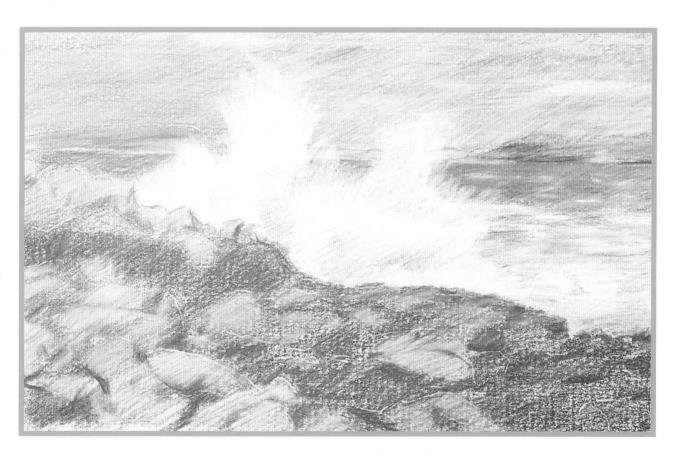

This composition is very simple. The main splash is placed centrally, the strong diagonal of the rocky shore sweeps upward from near the right-hand corner to meet the horizontal, distant coastline. Little of the picture area is taken up by the sea and the distant hills, but they are important in establishing the scale and depth of the picture.

4 Drawing interiors

Interiors range from small, domestic rooms to the vast spaces found in cathedrals, palaces, auditoriums, and railroad stations. It can be difficult to decide on how much of an interior to include in a picture, and—unfortunately—without considerable distortion of perspective, you are limited to what you can see in front of you. You can see more of an interior by moving farther back, until, of course, you reach the wall behind you. Small interiors are difficult to depict successfully for this reason because you cannot see much without turning your head.

You are likely to draw portraits or still lifes indoors and, if a significant amount of the room is included, these verge on being "interiors."

A domestic interior provides a wonderful opportunity to explore the play of light entering through a window, and these effects have been constantly used by artists through the centuries. Shafts of bright sunlight falling on the floor, walls, furniture, and perhaps over a figure or two is a favorite theme. Objects and people may cast strong shadows, producing dramatic effects.

A flight of stairs is a favorite subject for an artist because, pictorially, the rows of steps make a powerful image, as does any repeating pattern. If the steps spiral, all the better, since the possibilities of producing swirling abstract designs are endless. Such a drawing will test your skills with composition, proportion, and perspective.

An individual interior has been designed for a particular purpose, so you want to allude to that in your drawing. A portrait could be in a setting that reflects the sitter's occupation or interests; a kitchen scene could show the preparation of food, while a portrait of a chemist in his laboratory could show an elaborate chemical apparatus in the background.

A room with a view through a window or door onto a landscape introduces a whole new dimension to a picture. There is, on the one hand, the enclosed space of the room, and on the other, the open landscape beyond. The two contrasting regions can give a great sense of space—the effect of perspective is very evident, the trees or buildings in the distance appearing tiny compared with the furniture and objects in the room.

Interiors lit entirely by artificial light pose their own challenges; do you include the lamps themselves or keep them out of the picture? A single lamp in a living room is probably too dominant for most compositions, but a candlelit scene or a number of chandeliers in a large palatial room could be very effective. Such situations often produce strong shadows, and you can organize dramatic compositions around them. People sitting around a table with a single lamp in the center will have brightly lit faces, but their backs will be dark; their shadows may be projected onto a wall far from the table.

When drawing an interior, how do I determine the focal point?

There is no single answer to this question. Decide what it is that you want to emphasize and what you want your focal point to be. Is it the whole room, or just a detail in one corner of the room? Would somewhere between these two extremes be a good compromise?

Start close to one side of the interior, and look at your subject through a cardboard frame or by forming a rectangle with your thumbs and index fingers. Then, gradually step backward, including more and more of the room in the frame. Stop when you are satisfied that you have a good composition. Choose a sheet of paper that reflects the size of the subject and the scale to which you like to work.

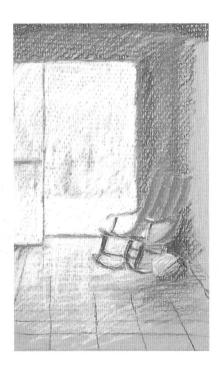

The striped chair by the window is the focal point of the picture. It lies just outside the window frame, but its arresting pattern draws the eye toward it. The corner has a certain intimacy about it. The trees outside are large enough in this view to draw them with some degree of detail.

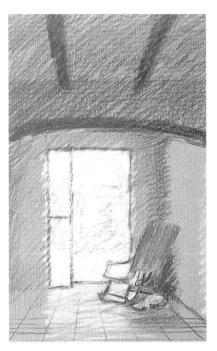

This is the same view but drawn from a point farther back. More wall and ceiling are visible, and the chair and window take up much less of the picture surface. They are, in fact, placed lower down in the picture, thereby allowing the two roof beams to contribute significantly to the composition. The chair is still the focal point, owing to the powerful eye-catching properties of the stripes.

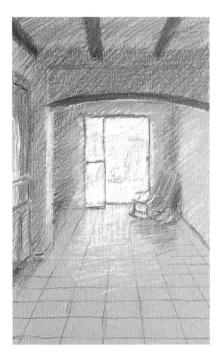

From this farback viewpoint, much more of the floor and the left-hand wall is visible. Most striking are the floor tiles, creating a pattern with converging lines that meet at a vanishing point roughly in the center of the window. The picture gives a feeling of a large spacious room in which the window is merely incidental—although the chair still remains the focal point.

Is there an easy way to draw floor tiles?

Drawing tiles, or any repeating pattern, is like drawing a straight line of posts or columns, as shown in "Is there an easy way to draw objects receding into the distance?" (see page 34). The same rules of perspective apply—the only difference is that here we are considering a horizontal surface. The floors in many seventeenth-century Dutch paintings are paved in black and white tiles, and the same is true of many floors today. You can draw paving stones, railroad tracks, or any regular repeating pattern the same way.

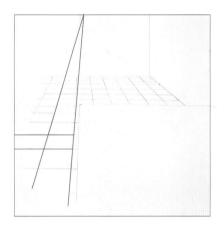

First, establish the angles of two lines of tiles that recede away from you. These are shown in red on this drawing. They meet at a vanishing point on the eye line, the level of your eyes looking straight ahead. Draw all the other receding lines to meet at this vanishing point. Next, draw the two nearest horizontal lines by measuring their distance apart (see "What is meant by drawing 'sight size'? page 24). These are shown in blue.

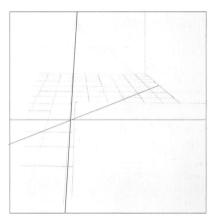

Draw a new diagonal line (shown here in green) across one tile, and extend it until it meets the next converging line. This shows the position of the next horizontal line, shown in yellow. Construct a fourth line, and however many more you need in the same way. The tiles become smaller as they recede into the distance, giving your drawing a sense of perspective.

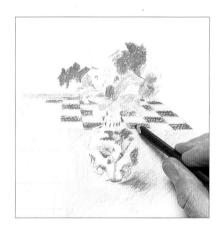

Draw the roses in the vase before coloring in the tiles, so that you can color in the tiles around the flowers. It is difficult to erase black or draw a lighter color on top of it.

The tiles are alternately black and white but their apparent color varies over the entire floor because of the way the light falls across the room. The white tiles to the right of the floor are less well lit than those to the left, so tone them down by adding a touch of pink. Burnish the whole floor area with Chinese white to give the floor an appropriate solidity and sheen. As a general rule, look carefully at every individual tile and assess its color. Remember, each tile will not necessarily be pure white or pure black throughout.

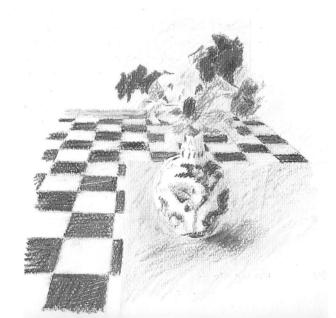

What is the best way to use daylight in a room?

There is no single best way to use daylight. In fact, there are often a number of ways it can be used to your advantage, even in a single setting. Perhaps the most dramatic effects can be created when sunlight streams into a room, brilliantly illuminating some items and casting deep shadows on others. You may like to compose such a subject with the window in view and daylight seen outside. The window and its immediate surroundings may then dominate the picture. Alternatively, the window may be out of the picture and the focal point likely to be something illuminated by the sunshine, such as the girl in this picture.

The girl's head is the focal point of this picture, so place it at the very center of the picture. Horizontal marks indicate the positions of the top of the head and chin, and a number of features of the chair and table.

Add shading to the girl and the chair to emphasize the shadow on her left side. It is helpful to indicate the strong tonal contrasts early on when drawing this type of subject. The window, unseen at this stage, is to the right of the girl.

The curtains, the girl's head and shoulders, and the chair form an approximate triangle in the lower-left corner of the picture. The strong verticals of the chair contribute to the action, which all takes place in the lower-left of the picture.

Now that the initial sketching is done, add some color to the girl, all the time remembering that light is coming in from her right. Using Chinese white, highlight her strongly illuminated right shoulder, arm, and left knee, but add a dark shade of blue to the parts of her right leg that lie in the shadow. Similarly, tone down shadow areas on her pale blue top, using dark blue and a touch of purple on her left-hand side.

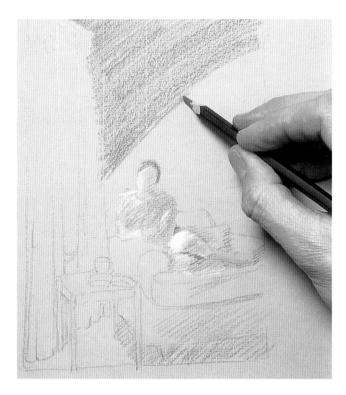

Now to the red wall, which takes up almost half the picture space. Large areas can be tricky to deal with, as they are seldom completely uniform. Look for any color variation—there is almost always some—and use it in your drawing.

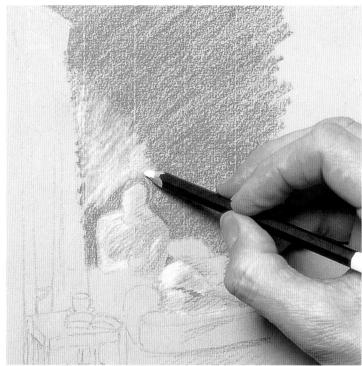

Sunlight strikes the lower part of the wall with a bright diagonal swath of pink. The soft pigment of the Chinese white used here embeds itself into the grain of the paper intensifying the color and giving a richer glow to the wall.

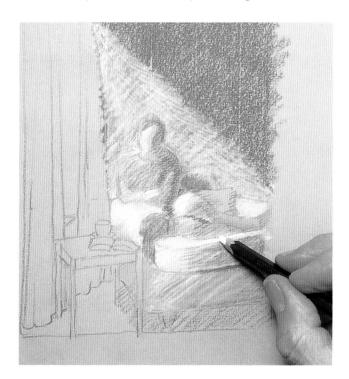

While the cream-colored armchair catches the sunlight on its right-hand side, its shaded parts are drawn in brown. Blend the two colors where they meet, initially by streaking the brown into the white, as seen at the corner of the cushion. More refinements can be made later on if necessary.

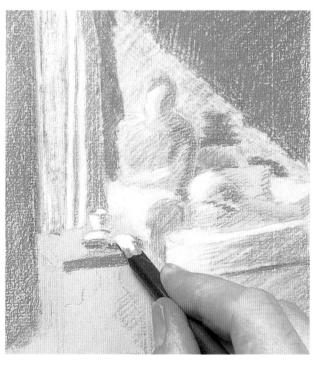

The teacup and book are important details because they stand out strongly. The cup is elliptical and visually links to the approximately round head. The open book's white pages are also eye-catching, contributing to this region of intense pictorial activity.

The deep shadow on the floor contrasts strongly with the sunlit parts. Combine brown, dark blue, and blue-gray hatching to create shadow so dark that no details are discernible. It is best not to use black, even to create the deepest shadows, as they will look too harsh.

Add more detail to the figure's face. The sunlit center of attention lies between the extensive dark lower left region and the dark upper red wall in an exciting but restful composition.

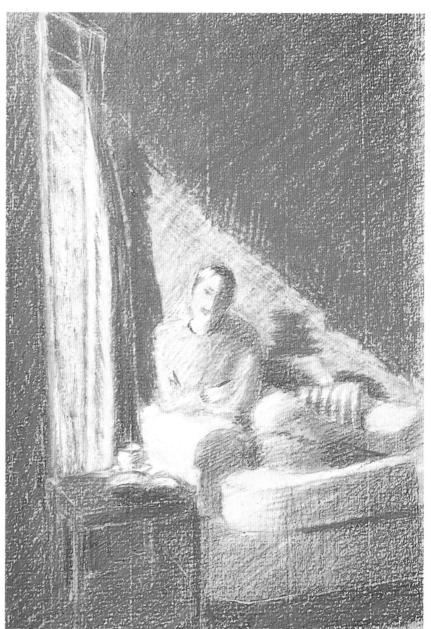

A few extra touches, such as further darkening the floor and the curtains, brings the drawing to completion. The overall effect is of a girl basking in the bright sunlight that streams through the window. Remember that sunlight does not remain stationary. While drawing a picture like this one, it may be necessary to stop work and resume the next day at the same time so the shadows are the same.

ARTIST'S NOTE

There are countless ways in which daylight can be utilized in a drawing. Experiment by shifting your position around the room and moving furniture. Try sitting a model against the light so he or she is silhouetted. Looking through a frame can help you choose your composition.

Below Drawing by David
Melling makes use of softly
blended and graded colors to
create a tranquil mood
appropriate to the subject in
a pool of natural light.
Although the gradations are
gentle, there is a strong
contrast of shades that gives
depth and impact to the
composition.

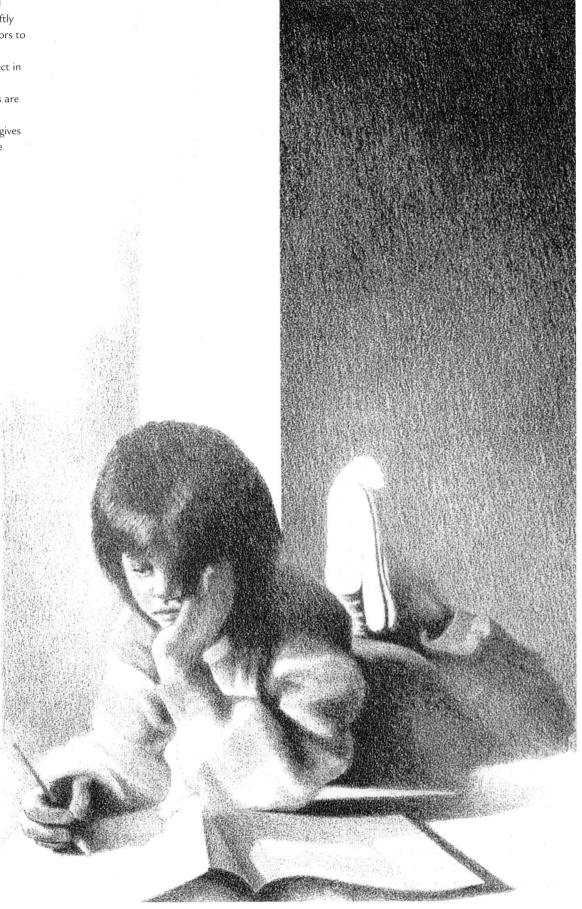

What are the best techniques for drawing artificial light?

A subject lit by artificial lighting can look much the same as if it were lit by sunlight—whether a model in a studio or a still life at home. However, if you want to draw the light itself, you need to think and carefully observe the effects the light creates. A light bulb will be very bright in relation to the rest of the room, and the objects in the room will have to be drawn quite dark to capture this. In the example below, the bulb itself is hidden by the dark shade, but its brightness is clear.

1 Choose a medium-gray paper and draw the outline of the objects in the room. When drawing a light source such as fire, a candle flame, or a night scene in which lighted windows show up against a dark background, it is often best to start with an even darker colored sheet of paper.

Draw the white glow from the lamp and the illuminated pink tablecloth. These are the main areas of light in the drawing and will be further illuminated as the darker colors in the drawing are added.

In reality, a white glow such as this beneath the lamp is visible only if there is dust or smoke in the atmosphere. Since the only light source directs its beam downward onto the table, the surrounding walls receive little light and are colored first in brown and then in blue. The choice of brown and blue gives a fairly neutral overall color and produces a more realistic tonal effect than a single dark color.

Part of the red carpet under the table is hidden from the light, so darken it with blue. The idea of this picture is to confine all the activity to the center, particularly the tabletop, where some detail has already been included.

Add more shading to the right-hand wall and the far wall, again, first with brown and then with blue, until you are satisfied with the result.

Deepen the tone of the carpet with brown. This is a warm color and efficiently darkens the red without seriously altering its character. If you are not sure exactly what color to add, try experimenting on a scrap piece of paper to see what different color combinations produce.

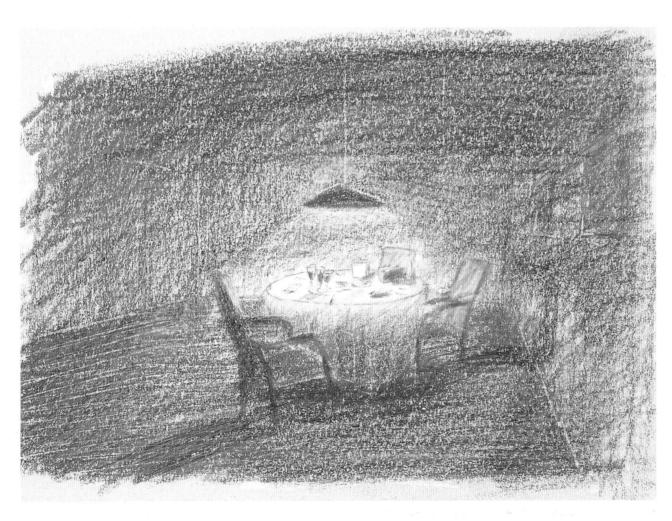

Darken the walls and the floor even more with purples to focus the attention on the center of the drawing. Now tone down the glow below the lamp so that the brightest feature is the tabletop.

How do I achieve the glow of a fire?

Fire is not a commonly chosen subject for a drawing or painting, but it can produce dramatic results. The glow of an open fire in a cozy interior, raging bonfires, forest fires, and even buildings on fire have all occasionally been portrayed by artists. Fire is best seen, and therefore best drawn, in dark conditions.

For drawing purposes, it is easiest to start on a dark ground and work upward tonally, the flames themselves being the lightest part of the picture. Study the fire, noting the typical shapes and colors that abound.

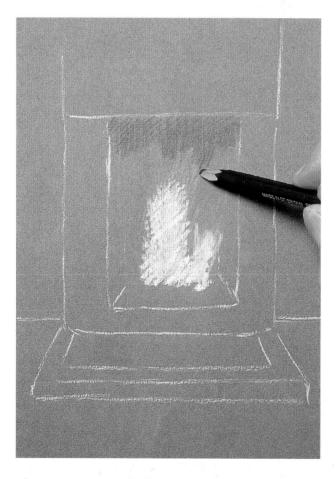

Select a dark paper for this subject; it will make any light colors such as Chinese white and yellow stand out brightly. Draw a simple outline of a fireplace in Chinese white. The flames must be bright in the final picture, so an underdrawing of white reflects light back through the yellow overdrawing. The flames are thinner, duller, and redder toward their tops, so draw these in orange instead of the yellow used at the base of the flames. They still stand out against the dark background. Blue, the complementary color to orange, creates a greater contrast with the flames than any other color of the same tone.

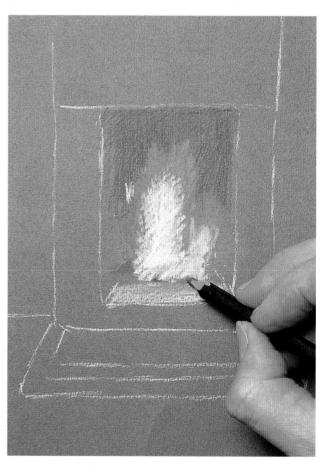

Even though little has been drawn yet, the picture already gives a convincing portrayal of fire. Sometimes, surprisingly little is required to create the most powerful images. It is important to know when to stop and to avoid the risk of overworking the picture.

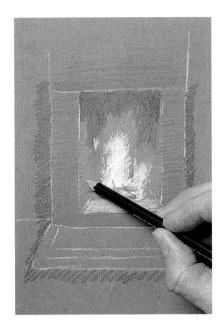

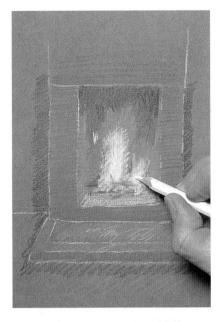

Give the front of the hearth and the floor in the foreground some glow with a little loose hatching of orange and yellow. The hottest region of the fire is low, where the coal or wood is burning. Here, the flame is at its brightest and whitest, so add an extra layer of Chinese white to accentuate this.

Use orange to represent the glow cast by the flames on the surrounding wall. If there were objects or people nearby, they too would receive the same glow and could be depicted in warm colors, such as orange or red.

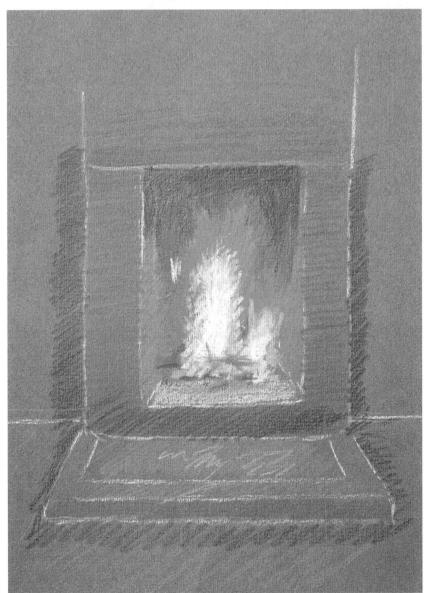

Although only a quick sketch, this picture gives an idea of how fire behaves. Do not be afraid to tackle even the most unlikely subjects—they are seldom as difficult as you fear. It is, as always, a question of looking and seeing.

A staircase may not at first seem to be an engaging subject for a drawing. However, the repeating pattern of parallel shapes gives a powerful image. The angular nature of a staircase can provide an excellent foil for the rounded forms of a figure. Stairs come in all shapes and sizes: a narrow, straight staircase in a small home; a curving wrought-iron spiral staircase; the wide stairs of a large institution; and the spiralling steps of a stairwell. It can be a rewarding exercise to tackle any of these, and you may produce some dramatic results.

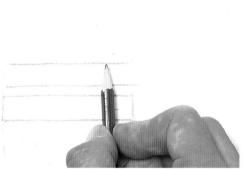

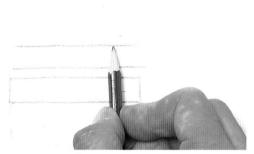

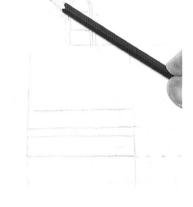

A straight flight of stairs viewed straight-on presents a pronounced linear perspective. The converging lines all meet at a vanishing point at the top of the stairs, and you face the challenge of accurately rendering the receding steps. Note the relationship between the two bottom steps and the bottom and top step. It is advizable to draw sight size when a subject, such as stairs, involves a lot of precise measuring (see page 24).

Measure the width of the bottom step and the top step (which appears much smaller, as it is farther away). Accurate drawing of these two steps is important because the rest of the drawing depends on them. Build up the rest of the drawing by adding other features, such as the window and bannisters.

Draw converging lines faintly from the outer edges of the bottom step to the outer edges of the top step, shown here in red. Continue these lines until they meet at the vanishing point-toward the window in this example. The banister tops can now be easily plotted, since they also converge at the vanishing point.

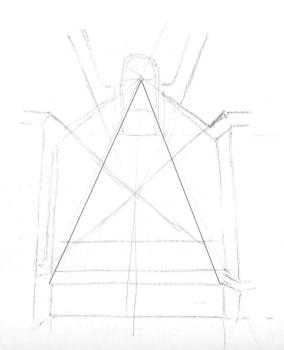

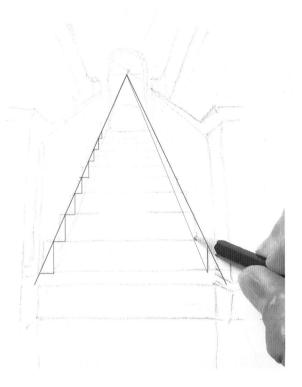

The rest is relatively easy. Here, a child is drawn sitting on the second step to add a focal point to the picture. The child also helps to determine the scale of the staircase. At the top are the banisters of two more staircases, one to the left and one to the right.

To obtain the positions of all the other steps, draw a faint line joining the lower left-hand edge of the second step and the vanishing point. This line is shown in blue. Now draw vertical and horizontal tie lines zigzagging up between these converging lines, shown in green. Do the same on the right-hand side, and you will have the positions of all the steps.

These uncarpeted stairs are wooden with blue vertical supports. The contrasting brown and blue form a striking pattern, an ideal contrast to the rounded form of the child. Now that the drawing is taking shape, erase the converging guidelines.

A staircase provides an unusual and interesting setting for a figure. There is depth and a feeling of space produced by the linear perspective of the converging lines.

Demonstration: Boy on a staircase

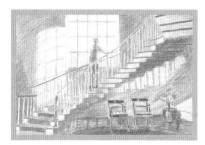

This somewhat grand staircase, with its sweeping lines, provides a dynamic subject. The drawing is taken from a small black-and-white photograph, which was enlarged using the traditional grid system (see pages 30–31). The colors are taken entirely from imagination. There is a large window placed centrally, but the sky is dull. In contrast, it is evident that two other windows are out of frame and

that bright sunshine is projecting the image of one of them on the left-hand wall. Sunlight from the other window falls on the wall beneath the staircase.

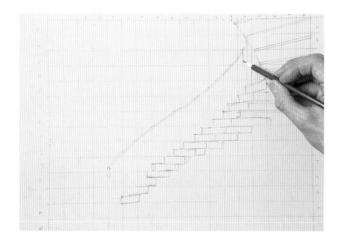

1 Enlarge a grid drawn over the original photograph threefold on a toned sheet of paper. Copy each square from the photograph to its corresponding square on the paper. Start by drawing the top banister posts.

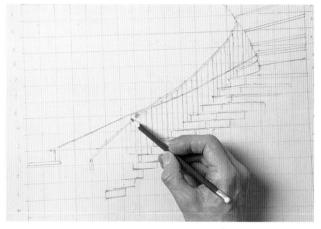

Copying from a photograph is relatively easy compared to drawing from life, which takes much longer, as every measurement has to be made carefully.

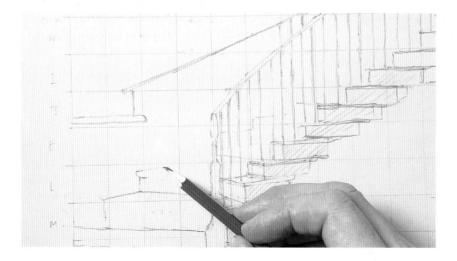

Numbered coordinates are essential so that you know what square you are working on. Notice that the darker parts of the steps are shaded with loose hatching, mainly as a guide for later. It is important to copy the intricate details of the staircase correctly. The excitement of this picture lies in the way in which the steps turn and the relation between the near and far railings. Don't guess at or rush such vital elements.

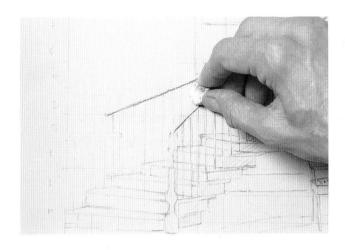

Draw the window frame and outline of the boy, and erase some of the guidelines on the blank wall. The two chairs have been shifted to the right from their positions in the original photograph. This is because they obscured the view of some of the staircase. Do not be afraid to make such changes if you think it will improve your drawing. Now that most of the outline drawing is complete, the grid is no longer of any use. Use a kneaded eraser to remove any gridlines from between the railings.

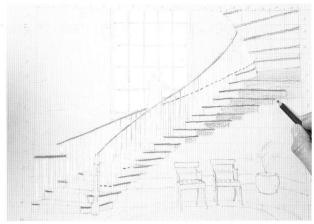

Block in the sky through the window with Chinese white. The white railings in front of the window are silhouetted against it, otherwise they remain white. Shade some of the darker undersides of the steps with purple and the adjacent wall with a blue-gray pencil.

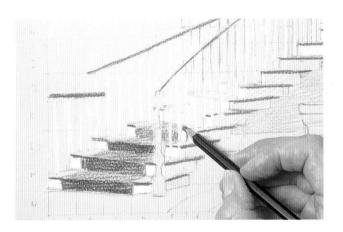

On this type of picture, details matter, particularly juxtaposed regular shapes of contrasting color and tone. Color the lower steps early on, as they are so important to the composition. The white-blue-white motif is repeated but gradually changes as the stairs curve around the bend.

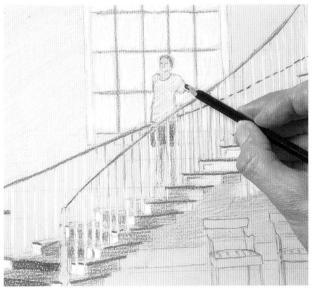

The focal point of the picture is the boy standing, outlined against the window. However, he is less interesting pictorially than the stairs. His white T-shirt against the white sky would appear darker in real life and must be toned down.

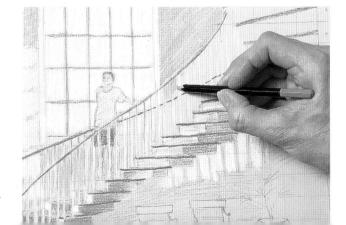

Color the wall toward the right with ochre. It now fills the spaces between the railings. The wall under the staircase has sunlight falling on it, which has first passed through some of the railings so that their shadows give a regular line of stripes.

111

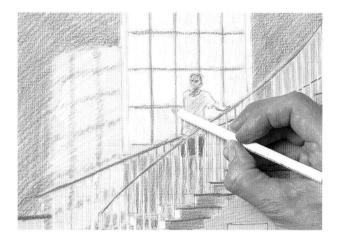

O To intensify the whiteness of the sky, apply a second layer of Chinese white with firm pressure. The shadow created by sunlight from a window outside the picture plane falls on the wall to the left of the window.

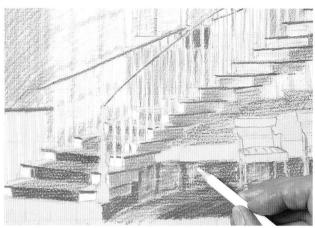

The circular, red rug at the foot of the stairs provides a splash of warm color to contrast with and complement the cool blue staircase carpet. Color the shiny wooden flooring in shades of brown. The shiny floor surface below the stairs reflects some of the window above it, including some of its cross bars. To achieve the reflection of the sky, apply Chinese white over the brown. Leave the shadows of the cross bars as bare brown in their correct places, vertically below the actual window.

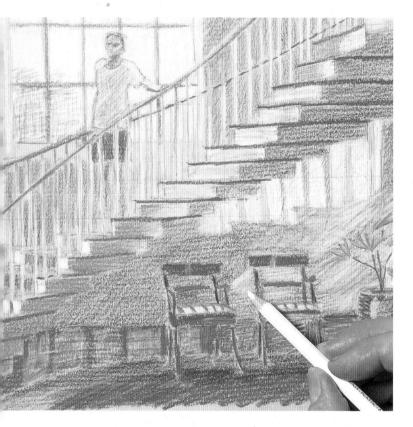

Next, draw the shadow of part of the staircase on the right-hand side of the drawing. The blue of the pot in the corner relates to the blue staircase, pulling attention from one to the other. In fact, they form the apices of a triangle with the boy above. Burnish the dimlylit wall beneath the stairs with Chinese white to give it a smoother appearance. The upholstery of the chairs echoes one of the themes of the picture—that of repeating patterns and stripes. Next, add the more minor details, such as the light reflecting on the chair backs.

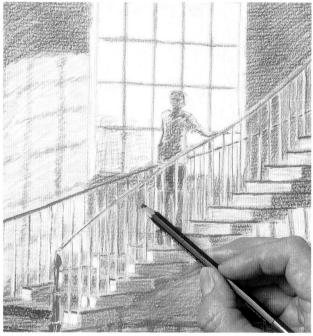

The railings receive sunlight from the window behind and slightly to the left, so keep the left side of each white and darken the right sides. Such details help to establish the direction from which the light is coming. Hatch some blue over the wall immediately to the right of the window. Use a sheet of paper to prevent the color from straying onto the areas of window glass and to create a sharp dividing line between the wall and the window.

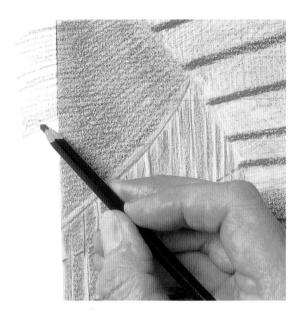

Tone down the walls even further by crosshatching with blue, purple, and brown. This will create a contrast with the paler areas. Next, assess the tonal contrasts in the painting and make amendments where necessary. Use a sheet of paper to mask the window if you intend to draw right up to the edge of the wall.

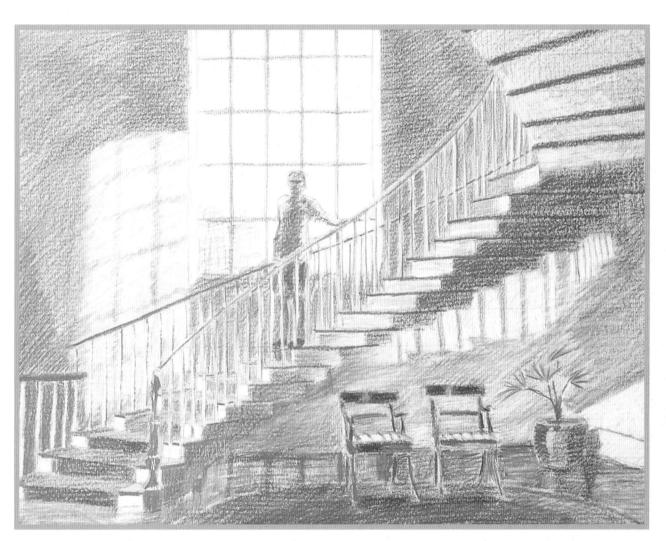

The focal point—the boy—presides over the spiraling staircase, causing the eye to halt at is follows the sweeping line of the stairs. This is a busy picture of interlocking shapes and repeating patterns. Splashes of bright color add contrast and interest to the generally neutral colors.

his chapter is primarily concerned with the human figure, but it also explores some of the ways in which animals, particularly birds, can be drawn. Drawing and painting peoplewhether portraits, full length figures, or groupsis one of the most challenging and satisfying of all branches of art. The drawing of the nude and the portrait are generally regarded as the best form of training for beginner artists. This is because we are so familiar with the forms of the human body that we instantly notice if thae drawing is even slightly wrong. Legs that are too short, eyes that are too high, or an incorrect curve of the forearm are easy to spot. If, on the other hand, in a still life you draw a jug too wide or too tall, it is not likely to matter much. Drawing the figure teaches you to look and see what is really there, and not what you think is there.

In fact, some previous knowledge can be a handicap. We know that a leg is long, but when it is viewed from certain angles, it becomes foreshortened, and its apparent length may be very short. Without seeing what it really looks like, one is tempted to draw it too long simply because one knows it is long. Conversely, one often doesn't realize quite how long the legs actually are, and, in a standing pose, there is the danger of drawing them too short—an all too common failing. Modeling of form can be done using shading, on the understanding that the

more a surface faces the light, the paler it is. A single, soft pencil is ideal to provide this treatment. With pen and ink, shading must be built up by crosshatching. Color can also be used to model form, and some of the examples in the following pages are worked up to a high state of completion using color pencils.

When attempting portraiture, a likeness in the face is what everyone strives for. Much of the likeness is derived from both the underlying tissue and bone structure. Careful modeling of the main structure is therefore of vital importance. A likeness also depends on the superficial details on the surface—the eyes, nose, and mouth. The secret with these is to build up to them gradually and not to be too precise until the end, if at all.

As well as drawing the human figure, you may want to draw your pet dog or cat, an animal in the zoo, or a wild animal. The general idea is the same, but the superficial covering of fur or feathers gives a different set of problems to contend with. Why not be happy with a photograph? The very act of drawing the animal forces you to look at it and scrutinize its appearance. Every mark you make on the paper represents some observation you have made of the animal, so the drawing ends up as your own personal representation of it. The drawing therefore provides a much stronger memory of a favorite pet than would a photograph.

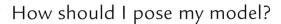

If the pose requires the model to remain still for long periods of time, then he or she must, above all, be comfortable and be able to hold the pose. A model requires a rest every three-quarters of an hour or so (unless the pose is extremely comfortable), and it must be possible for the model to resume the same pose after the break.

Standing, sitting, or reclining positions are most commonly chosen, but action poses, such as those of a dancer, operating machinery, playing a musical instrument, or simply brushing hair, can be interesting.

A short five or ten minute pose does not have to be comfortable; the only proviso is that the model can hold it for that length of time. First, plot the size of the head and the width of the body in relation to the model's height. On black paper, only lightening the tone is possible, hence the use of Chinese white. Leave the dark areas black and shade the paler areas with white. This is the exact converse of drawing on white paper.

Some people would find this crosslegged position comfortable for quite long periods, but others wouldn't. The sitter is holding and reading a book, which is a good way to prevent boredom setting in, particularly during a long pose. Many artists like to talk with their sitters, which has the advantage of keeping them alert and in the same position (although the head probably won't stay still). This pose is very compact; the legs, arms, and head describe a triangle. It gives a feeling of solidity, the figure firmly resting in her chair. If you are having difficulty planning a long pose, try a number of quick ones like these before making up your mind.

Here the model is sitting comfortably in a chair with legs outstretched. Remember that legs are much longer than you think, so compare all the lengths carefully. You could start by drawing an outline, beginning at the head and gradually working downward. Compare each new length with ones you've done previously. The sitter reads her book, which provides a valuable contribution to the composition as a whole, as it echoes the stand of the swivel chair and its sharp, angular shapes contrast well with the more rounded forms of the figure.

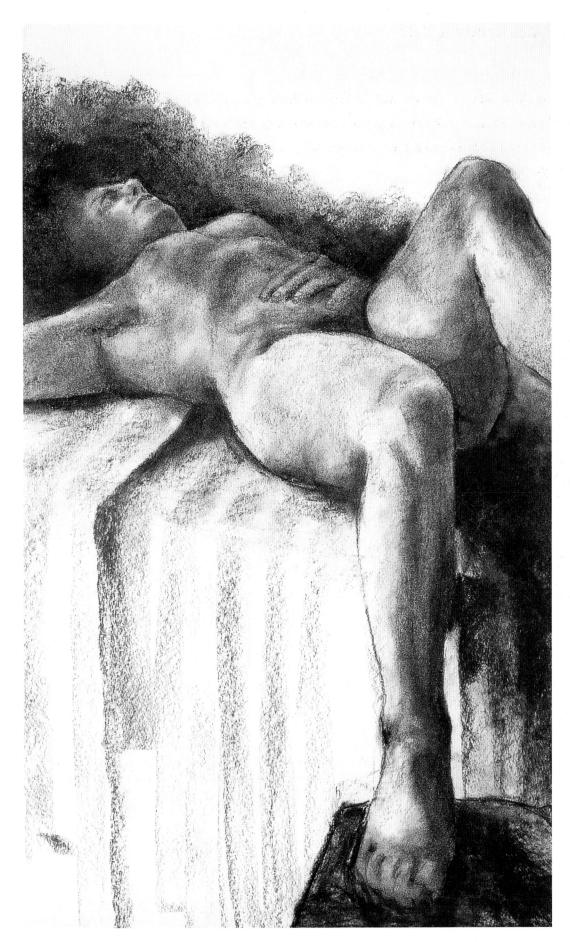

Left This pose is one that could easily be held by a model for a long period. As an example of the distortion caused by extreme foreshortening, this would be very useful to an artist.

Why do the legs of my figures often end up too short?

Legs are surprisingly long, and, very often, one does not realize this until a figure drawing is attempted. If you are lucky enough to be able to attend life classes, you will find the discipline required is invaluable training for all types of drawing because it forces you to accurately assess all the proportions in front of you.

However, without this training, you can quickly learn the rules of human proportions. When you come to measure the various lengths in a real human figure, bear these proportions in mind so that you will actually believe what you have measured to be true.

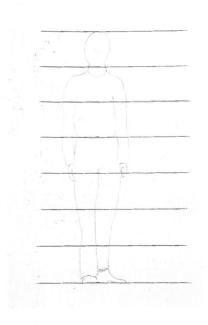

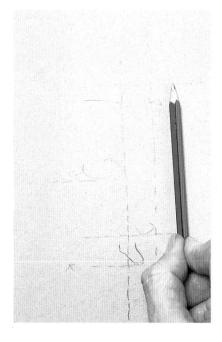

This girl is sitting upright, so her right thigh is foreshortened and her lap is not visible. Mark the distance between the top of the head and the right foot. It is equal to the distance between the tip of the pencil and thumb when the pencil is held at arm's length in front of the sitter, so this drawing will be "sight size" (see page 24).

Before attempting to draw a particular pose, be aware of the basic proportions of the human body. In general, the halfway mark from the top of the head to the feet is somewhere below the waist. An adult, from the top of the head to the toes, is roughly seven to seven-and-a-half head lengths.

Draw dotted guidelines to aid the measuring of the various distances. The lower legs are longer than the rest of the body and head put together. Use "plumb lines" to indicate what comes below what. The immediate surroundings of a figure should always be included—in this case, draw the part of the couch she is sitting on.

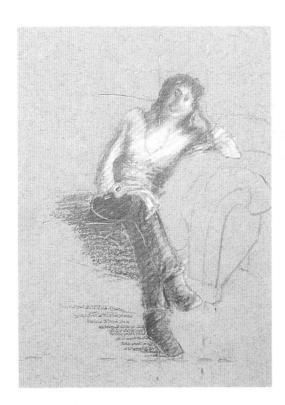

When drawing a figure, measure the distances carefully, always resisting the temptation to draw what you *think* is there rather than what really *is* there. It is not only in the human figure that legs are unexpectedly long. Without proper measuring, it is common for the legs of a horse, for example, to be drawn too short.

Left Other proportions worth remembering include the following: the hand is generally the length from chin to hair line, while a foot is about the same as the whole head. A child's head is proportionately bigger than an adult's, and that of a baby even bigger. When the arms hang freely, the elbows of a man are at waist level (and slightly lower in a woman), and the fingertips reach the middle of the thigh.

Right In this soft, gray pastel drawing by Diana Constance, the model was lying below the artist's eye level and was softly lit. Fine textured paper allowed even blending of the pastel. Life drawing practice is excellent experience for any artist.

What is foreshortening?

When a reclining figure is viewed from the feet end, the feet appear to be very big; we don't see much of the legs or body, and the head appears quite small because it is farther away. Moreover, the head may appear just above the feet. When we look at a person sitting in a chair facing us, his or her lap is foreshortened.

When a hand is pointed toward us, it may appear larger than the head. This apparent shortening, which occurs when we view things on a slant, is called "foreshortening." To draw a foreshortened figure is full of surprises because the parts of the body take on totally unexpected dimensions.

Measure the distances between strategic points carefully. Make horizontal marks for the top of the head, shoulder, hip, and where the foot tucks under the blanket. Draw a vertical "plumb line" from the model's right side of the head. Plot the distance between the knees using the distance between thumb and pencil tip, the same as when it is held at arm's length to the model.

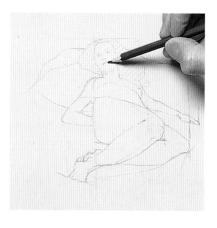

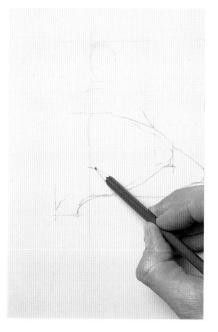

Draw both the knees, and mark the position of the buttock. Already it can be seen that a large proportion of the picture surface is filled by the legs. Without careful measuring, the legs are invariably drawn too short.

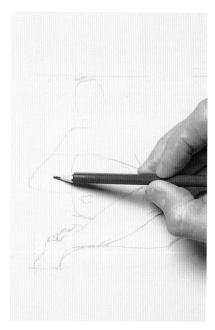

With the contour of the legs and feet complete, now draw the arm. Because everything so far has been drawn with great accuracy, the relaxed pose of the model is already apparent, even though you have not yet reached the stage of a complete line drawing.

The head is slightly tilted back on the pillow, so the eyes, nose, and mouth appear higher than they would if the head were upright. The nostrils are visible, and the mouth is an inverted "V" from this viewpoint.

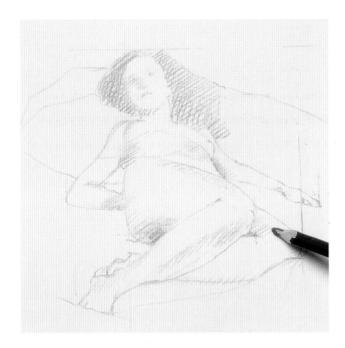

The model is illuminated by a diffuse overhead lamp and so has little strong shadow. Hatch and crosshatch the few areas that are in shadow, and color the model's black hair—this is black and not caused by shadow.

Add a little color now. Apply a uniform hatching with ochre, followed by flushes of pink and highlights with white. Emphasize the paler edges of the body by shading the surrounds with blue-gray.

This reclining nude is propped up on pillows and is viewed at a steep slant. Her right leg is angled so we see almost the full length of both the thigh and shin. Her torso is highly foreshortened and consequently takes up very little picture space. Foreshortening and the effects of perspective result in her head appearing small and her feet and shins large. Since we are looking down at a steeper angle to the nearer parts of the figure, these are less foreshortened than the farther parts, which are viewed at a shallower angle.

How should I start a portrait?

First, decide on your subject matter and the scale on which you want to draw. Then select a suitably sized sheet of paper, making sure that there is enough space for you to complete your drawing. Being confronted with a blank sheet of paper can be very daunting. However, once you have made a single mark to represent-say, the corner of an eye-this can act as a point of reference for many of the dimensions in the drawing.

The corner of the model's left eye is marked as a dot. Choose its position so that there is ample room for the rest of the picture to develop around it. A portrait has to be very accurate if it is to have any resemblance to the sitter, so draw this picture "sight size" (see page 24). Plot the positions of the nose, mouth, and chin in relation to the corner of the eye, although these marks are for reference only and are not intended to be part of the final drawing. Now add some loose shading of the darkest recesses of the eyes, and the portrait is underway.

Within the dark areas are even darker passages, such as the eyes and folds beside the nose and mouth. Without being too precise, shade these regions a little more heavily. Sharp detail must be avoided at all costs at this stage.

Notice how high the top of the head is in relation to the eyes, which are, perhaps unexpectedly, less than halfway up. The model is illuminated by a light source to the left, so the right side of the face is in shadow. Loosely shade in these areas with a soft pencil.

Add more shadow around the nose, mouth, and forehead to give personality to the face. Darken the lips to indicate the slight opening of the mouth where the teeth are revealed. The corners of the mouth should be quite dark.

Establish the main dark and light areas with a 3B pencil. This serves as an underdrawing for the color laid on top. This is by no means the only way to approach a drawing. You could apply color at the start. Use pink for the lightest areas, ochre for intermediate tones, and dark blue for the darkest passages. There is still no sharp detail, which is much easier to add toward the end. It is sometimes best to avoid detail altogether, because if it is even slightly wrong, then the likeness to the sitter is lost.

Add some white highlights to give sparkle to the eyes and teeth. There should now be more modeling on the left side of the face. Begin drawing the ear as well as some of the pale background. The color and brightness of the background will affect some of the highlights on the figure, so its color cannot easily be changed at this stage.

Burnish much of the face with Chinese white to increase the contrast with the darker areas. Leave some of the original tinted paper uncovered so that it serves as an intermediate color. Keep looking at the model to see what is actually there, and ignore what you think ought to be there.

Begin a portrait by taking accurate measurements to plot the positions of the main features, such as the top of the head, nose, mouth, and chin. Shade loosely to establish the darker areas first, and only gradually attend to increasing amounts of detail.

How should I draw a mouth?

While the mood and character of an individual can be assessed by looking at the eyes, the mouth is responsible for much of our ability to recognize the individual. Hence to achieve a likeness, it is important to get the mouth right. The secret is to avoid contours and to build up the mouth with shading alone. The only sharp line in a mouth is where the lips meet. There is usually a shadow at the corner of the mouth and under the lower lip.

Just as a guide, position the chin, lower lip, upper lip, and the point where the lips meet with faint marks. There is quite a marked shadow under the lower lip, so indicate this with some tentative shading. The upper lip is quite dark in relation to the skin above it (and even darker if lipstick is worn). To begin with, shade this lightly, without establishing any final definition. Notice the characteristic dark corners, particularly on the right side.

Although defined only by a little shading, this mouth resembles the sitter's. Parts of the drawing are no doubt inaccurate, but this doesn't matter because nothing is stated with too much precision. It is often best to keep to the side of vagueness when attempting portraiture.

The little central groove descending from the nose to the top of the upper lip lies between two ridges, each usually illuminated slightly more on one side than the other. Hence, two darker regions appear below the nose; one small, the other continuing on the right side of the upper lip.

The only continuous line is that where the lips meet, and even this is rather tenuous. Drawing on a mid-tone paper enables you to add highlights. Add the lightest reflections on the lips, chin, and nose in Chinese white.

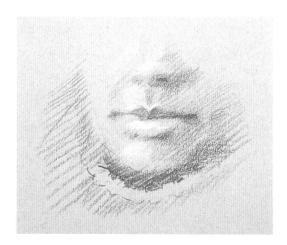

Why are the eyes often too high in my portraits?

Children usually draw eyes much too high because it is natural to think of them as being at the very top of one's head. In reality, the face occupies a surprisingly small part of the head, the eyes being about halfway up and the nose, mouth, and chin being crowded below them. Again, measure the proportions carefully. As the head is tilted back, the crown and then the forehead disappear from view, and the eyes become the most prominent feature. Conversely, if the head tilts forward, then the crown dominates and the eyes and nose retreat downward.

LOOKING STRAIGHT ON

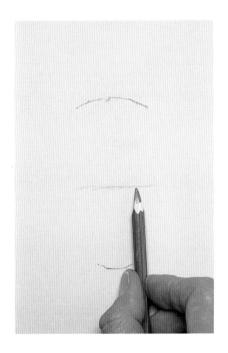

The three lines here represent the position of the top of the head, the center of the eyes, and the chin. Measure these proportions accurately with respect to one another. Note that—seen straight on—the eyes are almost exactly halfway between the chin and the top of the head. Include the mouth, the line representing the position where the lips meet. Plot the positions of the base of the nose and the hairline. The forehead and crown occupy half the space—not what one would normally assume at all.

Draw this sketch with a terracotta conté crayon, a soft medium suitable for rapid shading that gives a high color density. A portrait begins to take shape when the nose and mouth have been defined.

The model is posed with her head on the level, and we are looking at her from the same height. Only now that the drawing is complete can one be convinced of the fact that the eyes are indeed halfway up the head.

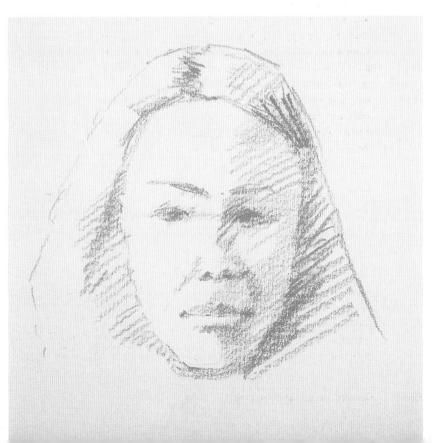

Draw the same model with her head tilted back, in the same style, to illustrate that now the eyes appear higher in the head. As before, measure "sight size"—the distance of the tip of the pencil to the thumb coinciding with the real thing when held up to the subject at arm's length. (See page 24.)

The area under the mouth appears larger, the nostrils more visible, and the crown has now disappeared. This is a common angle for a head in many poses, particularly those in which the model is reclining and the head is resting on pillows. The distance between the eyes and the eyebrows is slightly greater now, while the eyes themselves are narrower because we are viewing them from a low angle. Mark the width of the head to put the facial features into context.

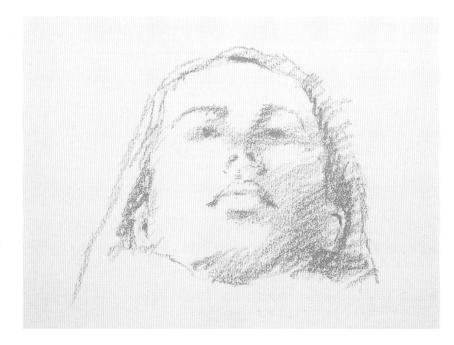

Note how low the ears are now that the head is tilted back; they are lower than the mouth. The face is said to be foreshortened (*see* page 120), resulting in unexpected juxtapositions, such as the tip of the nose appearing almost level with the eyes.

LOOKING DOWN

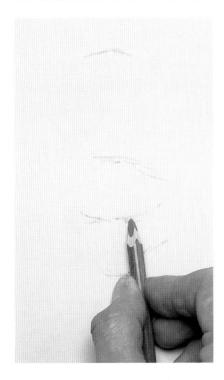

Here the same model is allowing her head to hang forward. Mark the positions of the eyebrows and eyes in relation to the chin. The eyes come about a quarter of the way up the head when it is in this position.

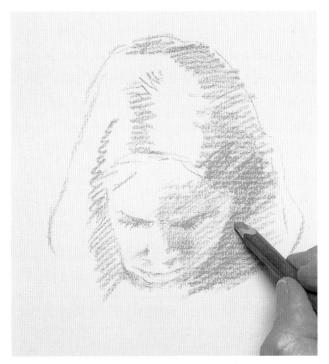

The crown dominates, the hair taking up half the head area, while the face fills only a small fraction of the total area. The eyes are almost hidden by the eyebrows, and the chin is not far from disappearing out of sight. The modeling of the hair has progressed considerably. The model's hair and face are in shadow on the left-hand side. Add the region of deepest tone which is just beside the face.

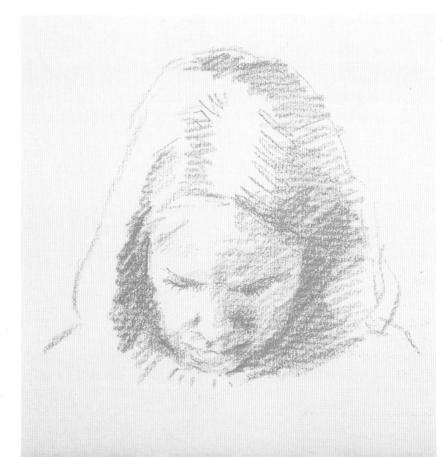

How can I draw hair realistically?

As with drawing fur, ignore individual hairs and look for the major dark and light areas. Hair is generally silky and shiny and reflects light normally. A head of clean, well-brushed straight hair will have one major highlight, since all the hairs will bend together and therefore reflect the light at the same place. The exact position of the highlight will depend on the relative position of the light source. Curly hair has a more complex pattern. Each curly lock has its own highlight, and the deep recesses between the locks are dark.

When drawing the shape of the head relative to the face, notice that the face is surprisingly small. Draw a couple of long thin locks of hair around the face, but at this stage, shade in only the deep shadow on the crown. This is dark because hair lying at that angle only reflects light from beyond, and in this case, there is only a dark wall beyond the sitter.

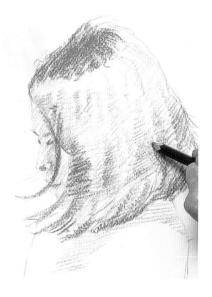

The main highlight is just below the dark crown. Keep this largely clear in this drawing. Below the highlight, this hair hangs in curtainlike vertical waves. One side of the wave reflects light to the viewer, and the other side remains dark. Draw these dark wedge-shaped areas.

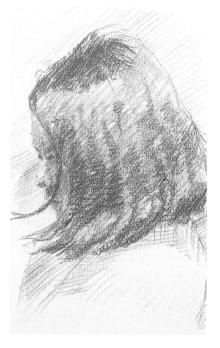

Shade the whole head with a layer of hatching, particularly the darker, vertical wave region. The highlight below the crown is still relatively pale. Notice that where the hair lies at a shallower angle over the shoulder, it reflects light toward us, appearing pale but not as pale as the main highlight. The darkness or lightness depends on the angle at which the hair is lying.

ARTIST'S NOTE

It is best to shade hair with pencil strokes at approximate right angles to the direction of the hairs. On the other hand, wispy locks of hair or the odd individual hairs that fall out of place should be drawn in the direction of the hairs.

Q

Hands are notoriously difficult to draw but well worth the effort—if only as an exercise. Bear in mind their structure. The fingers all hinge in only one plane, but the thumb can swivel so that its joints hinge in a different plane from the fingers. These digits are a series of approximate cylinders, while the rest of the hand is a flattened structure—convex above, concave on the palm side. When drawing the hand, accurate observations of lengths, proportions, and negative shapes are important. The slightest errors will make your drawing look wrong.

CUPPED HANDS

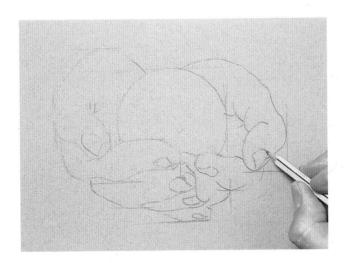

This is the start of drawing a red ball held in cupped hands. First, establish the distances between the fingers. The shapes between the creases, edges, and folds can be thought of in abstract terms, but you must be aware that the fingers are articulating cylinders. Extreme accuracy is worth striving for right from the beginning. Include the finger nails early on to aid in the identification of the fingers—otherwise you have a network of lines without knowing what they mean. Note that each nail grows from a depression in the finger and culminates in a slight arch.

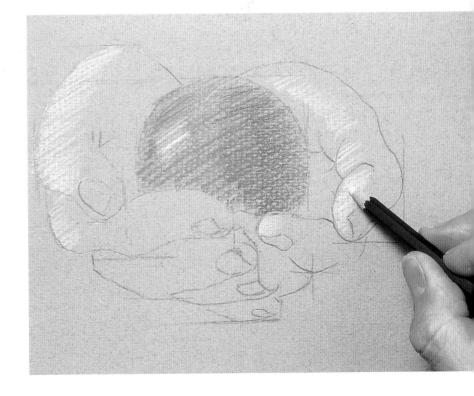

Add color to the red ball first. Light is coming from the left, leaving the right side in shade. Hatch over the initial layer of red with two layers of gray-blue, one layer extending farther to the left than the other.

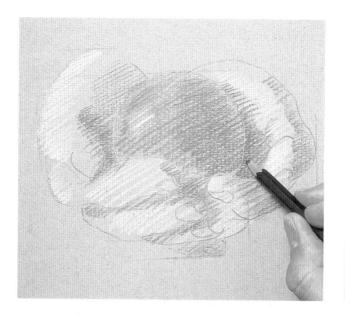

Hatch the underdrawing in purple to establish all the parts of the fingers in shadow. Use pink to hatch in the lighter parts. The order in which you add colors will make some difference to the final effect, but it doesn't matter if you change this.

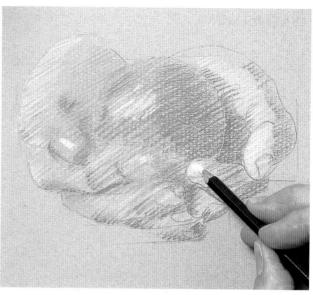

It can be instructive to experiment on a separate sheet of paper to see the effects that the order of application has on different colors. Here, orange has been added to the left side and extreme highlights added with Chinese white.

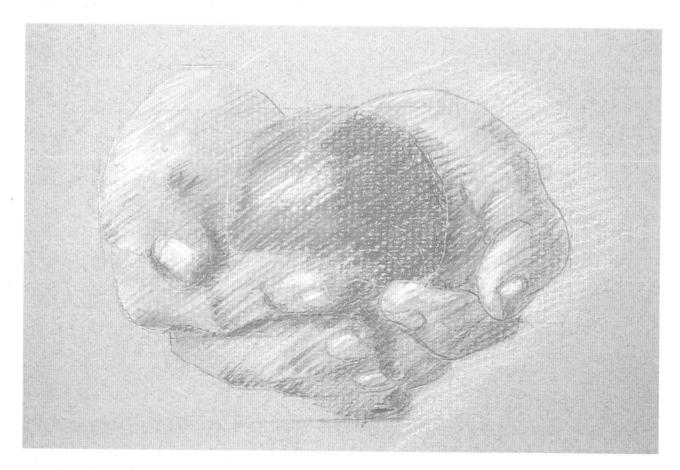

Getting the drawing right from the start ensures that the fingers and thumbs have the correct thickness and length and appear with convincing articulating joints. The ball must also nestle comfortably within the hands.

OPEN HAND

Mark a number of measurements on the paper as "landmarks" around which to base the rest of the drawing. Among them are fingertips, the lower end of the thumb, and the point where the thumb appears to join the first finger. Use the pencil as a measuring tool.

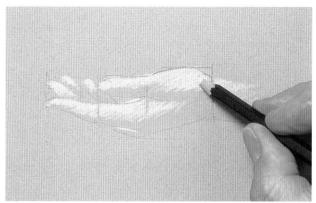

The light source is above the hand, so the lower parts of the hand are in shadow. Shade these in ochre. Draw the brightly illuminated upper parts with pink. As the light parts merge with the dark parts, intermediate tones are present, so mix the hatching of the two colors.

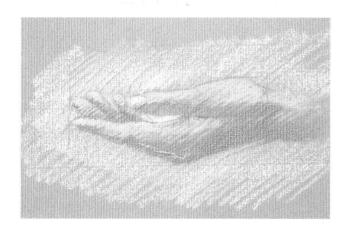

Better the very darkest areas in dark blue and loosely hatch the ochre regions, where necessary, with blue, to gradually tone them down. The thumb takes a dominant position when the hand is seen from this angle, so model its form carefully, all the while looking to see what is there in front of you.

The tendon that connects the thumb to the wrist leaves its own shadow, so shade it with blue. The fingers curl slightly upward, a characteristic of a relaxed hand. However, this pose cannot be held for too long, so either work quickly or allow your model frequent rests.

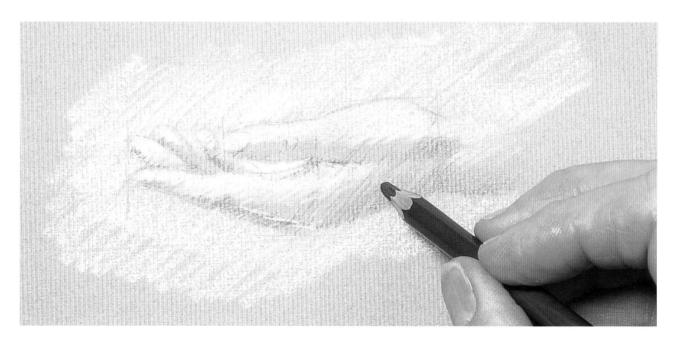

Demonstration: Figure looking out of a window

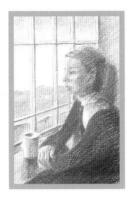

A seated figure sits at a window gazing absentmindedly at the sea. The subject poses a number of pictorial challenges: a portrait in profile, a hand, a distant landscape, and an enormous tonal range extending from the brightness of the sky to the darkest shadow. Linear perspective is featured in the window frames, there is an ellipse in the mug, and the shiny shelf gives strong reflections off its surface. The main color theme is red, blue, and white. A picture such as this, perhaps done on holiday, will bring back memories much more powerfully than any photograph will.

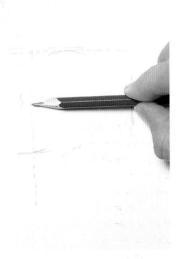

Many of the pictures in this book are drawn "sight size" (see page 24), and this is no exception. Plot the distance from the corner of the eye to the back of the ponytail with a pencil. Measure the vertical distance from the chin to the top of the head.

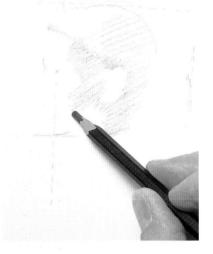

Remember that the underlying structure of a head and face is as important, if not more so, than the superficial features such as eyes, nose, and mouth. The underlying structure is responsible for the main shadows, so establish these accurately first. Block in the main shaded areas of the head with dark blue. If you have difficulty in distinguishing these areas, try blurring your vision by squinting your eyes or removing your spectacles. In this way, all superficial detail is eliminated, and all you will see are the main dark and light forms.

It is helpful to draw a model simultaneously with any surroundings that are close to the model. Hence, draw the window frame. This increases the number of reference points, which will help with the rest of the drawing. Surroundings far behind the model are of less help because any slight movement of your head causes a large shift in their relative positions.

Watch for the negative shapes created between the window frames and the figure and within the figure itself. Getting these right helps to draw the figure correctly and in relation to its surroundings. Always have an eraser on hand, and don't hesitate to use it. Watch for your mistakes, and remove them as they occur. Here a kneaded eraser is removing some blue shading.

Draw the darker shadows of the face in blue. Now add a light brown to it. Pigment catches on the raised grain of the paper in tiny patches, so a mosaic of blue and brown results. The eye mixes these colors in a process known as "optical mixing." As layer upon layer is added, a rich texture of indefinable color develops. The first layers gradually become obliterated by the later layers as you steer toward the final effect. Apply another layer of blue to the cheek. Underdraw the dark shadow of the hair with dark blue and the paler parts with ochre. Hatch a dark brown over the blue areas so the combination of these two pigments is closer to the desired effect.

The pale blue garment is burnished with Chinese white, particularly where it catches the light most. This forces the pigments into the grain of the paper and gives a smoother effect. Coat the darkest parts with brown to establish its tone—you can modify it for color at a later stage.

Although half the hand is covered by the cuff, the fingers are visible. Draw these carefully in outline. A hand is arguably the most difficult subject of all to draw. Look at the lengths of the fingers and the extent to which each can be seen, all the time being aware that, basically, they are articulating lengths of cylinders. Shade the hand, initially given a uniform coloring of pink, with blue in the relevant areas. This could be done with brown or a number of other colors, but the resulting mauve harmonizes better with the picture's main color theme of red, blue, and white.

The reflection of the mug on the shelf is simply its inverted image. To the left and right of this is the reflection of the sky through the window. Draw this by burnishing Chinese white over an initial brown layer. The angle of this crossbar is virtually horizontal and therefore easy to draw correctly. Note, however, that if you shift your position even slightly, its angle will change. The apparent angle of the lower crossbar is obtained by tilting a ruler until its angle coincides with that of the bar and then carefully transferring this to the drawing, keeping its angle constant throughout

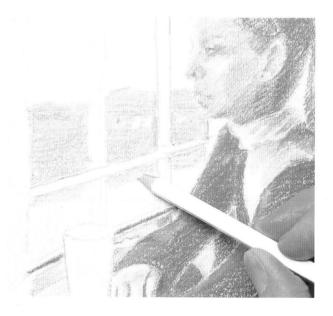

The sitter's head and the artist's head are at the same height. Both are considerably elevated above sea level, so the level of the horizon in the distance appears lower than the eyes (*see* "How high should figures be placed in a landscape?" page 76).

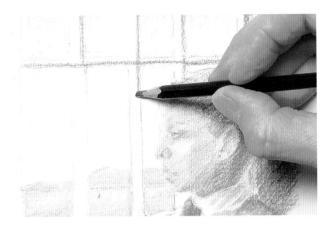

Color the sky initially in blue, most densely at the top.
Color the distant hills in light violet and the sea in more blue. Burnish all three areas with Chinese white to enhance their colors but also to render them paler. Color the dark shadows of the window panes in Prussian blue.

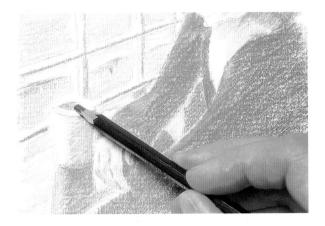

Accentuate the tapering cylindrical form of the mug by shading, which becomes increasingly dark the farther it curves away from the light. The inside of the mug is dark on the window side and gradually pales to the right as it receives more light.

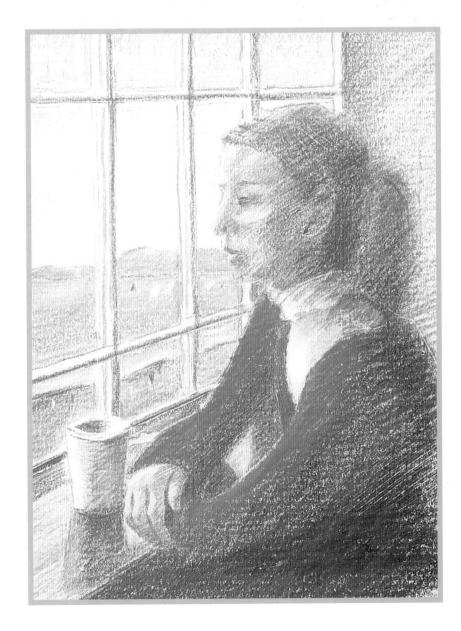

The focal point of this composition is the sitter's head which rests at the apex of, essentially, a large triangle made by her arms and shoulders and the shelf she is leaning on. Her head is a third of the way from the top and a third of the way from the right in accordance with the "rule of thirds," which tends to give a more harmonious and satisfying image.

As a general rule, the larger the bird, the longer it will tend to rest in a still position, and therefore the better it is as an artist's model. Professional bird artists observe their subjects in the wild through a telescope mounted on a tripod, making quick sketches and notes and then building these into a final picture back in the studio.

Birds in an aviary are an easier proposition, but still the smaller ones do not stay still for long. One easier way to draw the more fleeting poses is with the help of a photograph, as the demonstration below shows.

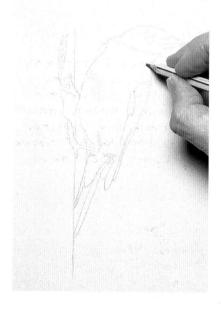

Using a photograph, copy and trace the pose of the bird. Drawing the feathers is much more complicated and requires careful observation of the bird in front of you.

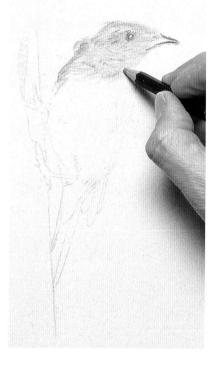

The shape of the head, including the bill, is responsible for much of the bird's character, so this is a particularly important part to get right. Make sure that you get the correct position and size of the eye. Add a white highlight to indicate the reflection of the camera's flash.

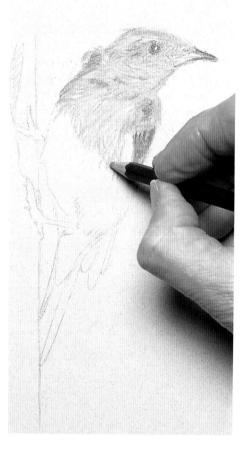

Make pencil strokes mostly in the direction in which the feathers lie. The only exceptions to this are the shadows, which you should hatch at right angles.

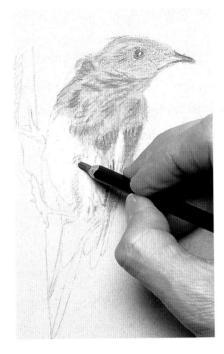

Indicate those feathers that stray over feathers of another color with individual pencil strokes. Give the same treatment to any feathers that are ruffled out of place.

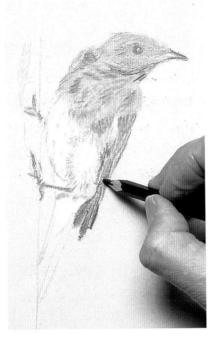

The flight feathers of the folded wing are long and lie overlapping each other, so that a dark shadow is cast by each one on the next. Draw these shadows as long, thin lines with a blue-gray pencil.

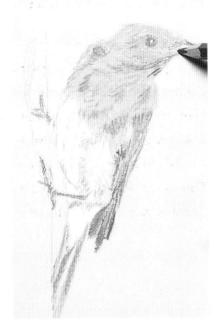

Bristles around the base of the bill project into the air. Draw these as single strokes of the pencil. The blue tail feathers are stiff as are the flight feathers. The much shorter down feathers on the underside of the bird and on the head are fluffy and serve to keep the bird warm.

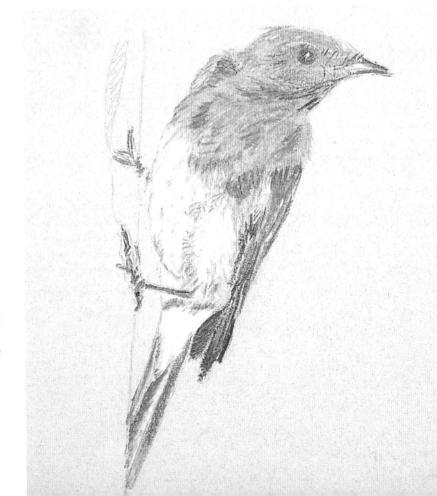

An understanding of the feather arrangement of a bird is helpful when it comes to drawing one. The wing is particularly complex. If you get the chance to study a dead bird, try opening and closing the wing to see how the feathers are arranged in flight and how they fold over each other at rest.

Demonstration: Parrot in flight

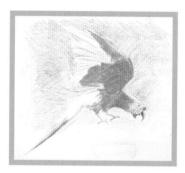

This macaw coming in to land is taken from a small colored photograph. The drawing or painting of birds from life is a specialized art and needs infinite patience. Squaring up a photograph into a large colored (or black and white) drawing can be highly rewarding. Few natural subjects, apart from flowers, can provide the dazzling or intense colors found in some birds. Many birds show irridescence in their plumage, so when they move the colors change—certainly a

challenge for the artist! The less brightly colored birds are also a delight to draw, exercising your skills in conjuring up a range of subtle browns.

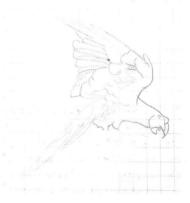

Trace the photograph of the macaw.

Draw a numbered grid over it. Draw an identical grid but twice as large on the paper for the final picture.

Copy and enlarge the contour of one of the flight feathers, square by square. (See page 30 for details of this method.)

Continue to draw the outline of the bird. Transfer each square carefully by noting exactly where the line you are drawing crosses the gridlines. Compare the drawing on the tracing and the larger drawing next to it, and you will see that one is an exact enlargement of the other. Use the narrow eraser on the end of your pencil to remove the gridlines when the line drawing is complete. You do not have to erase the gridlines if you think the subsequent coloring will be dense enough to hide them.

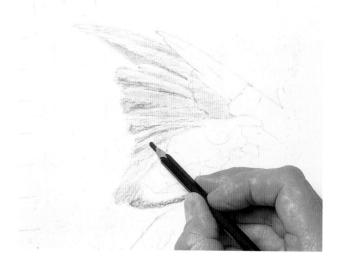

To make the blue of the primary flight feathers as brilliant as possible, add a preliminary layer of Chinese white under the blue. You could apply white over the blue, but the effect will be a little duller. The inner edge of each flight feather is fairly dark. Use purple to darken the blue pigment already laid down. If in doubt, try it out on a piece of scrap paper. Try darkening pale blue with other colors, such as gray, dark green, or brown, or a combination of them.

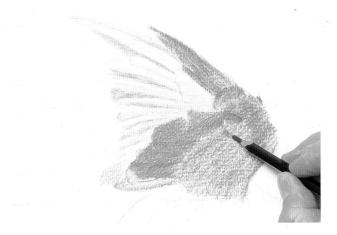

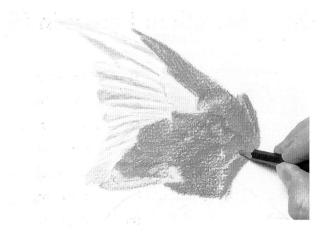

The color density of the scarlet is too weak because pigment has not penetrated the teeth of the paper completely. Apply a second layer of scarlet using more pressure. Depending on the manufacturer, too much force will break the tips of certain colored pencils more easily than others.

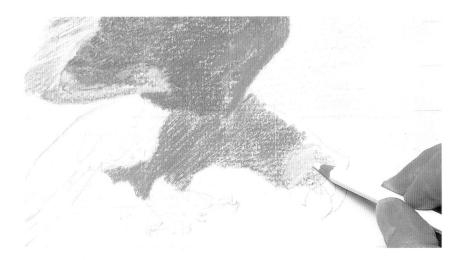

The down feathers of the underparts are the same scarlet as the underwing coverts, so color them the same way. The "face" is bare skin and is duller and paler in color. Burnish the scarlet with Chinese white to achieve a suitable effect.

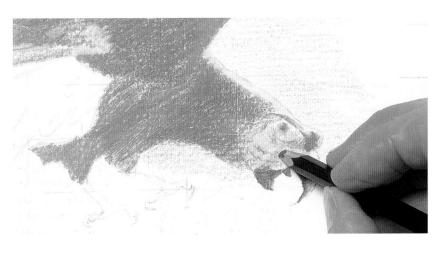

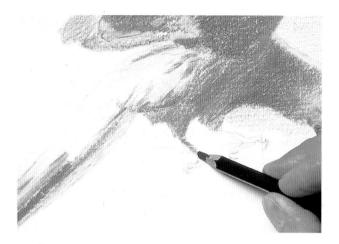

Covering the bases of the tail feathers of all birds are the under- and upper-tail coverts, which, like the wing coverts, are small but not fluffy like the down feathers. The tail coverts in this macaw are the same blue as found on the upper side of the flight feathers. The tails of most birds culminate in strong feathers similar in structure to the flight feathers. In this species, the tail feathers are blue except for the outer ones, which are red. The arrangement of the toes varies among birds; in all parrots, two toes face forward and two backward. Use a dark color to draw these in.

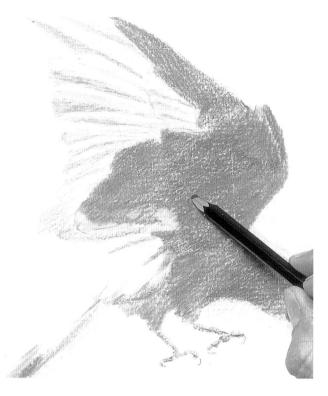

Now assess the whole drawing for tonality. Darken the underwing by adding a thin layer of Prussian blue. At this stage, it is sometimes difficult to know when to stop work. In this case, since nothing is glaringly obvious that needs to be done, consider the bird itself finished.

The background in the original photograph is of green leafy trees. However, green will clash with the blue and red of the bird and will swamp the drawing. Instead apply a pale blue to indicate sky. This background will complement the bright colors of the parrot.

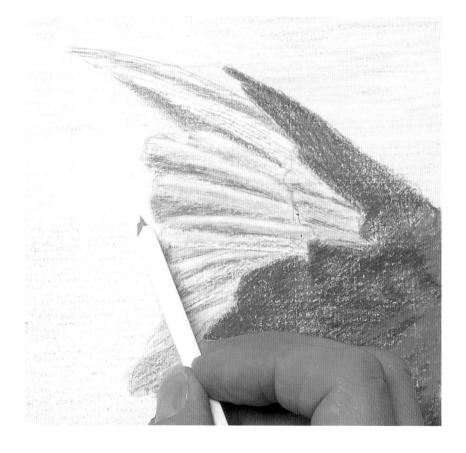

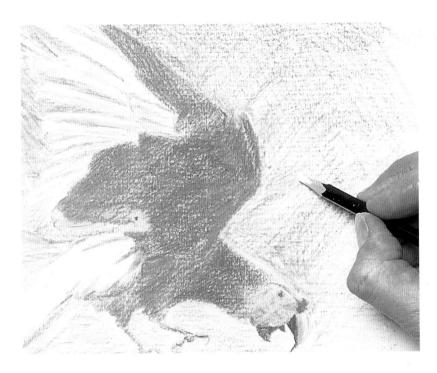

12 First lay the foundation for the blue with Chinese white. Hatch the blue over the white. Very often, the simpler the color scheme of a painting or colored drawing, the more effective it is. Thus the main colors of this picture are restricted to blue and red. Burnish the blue with Chinese white to smooth down the pencil strokes and make the blue paler.

Large birds tend to be easier to observe and to photograph in flight. It is possible to watch soaring storks, cranes, or eagles and sketch them at the same time, perhaps with the intention of building your sketches into a more complete picture. The use of photographs, though, is more practical.

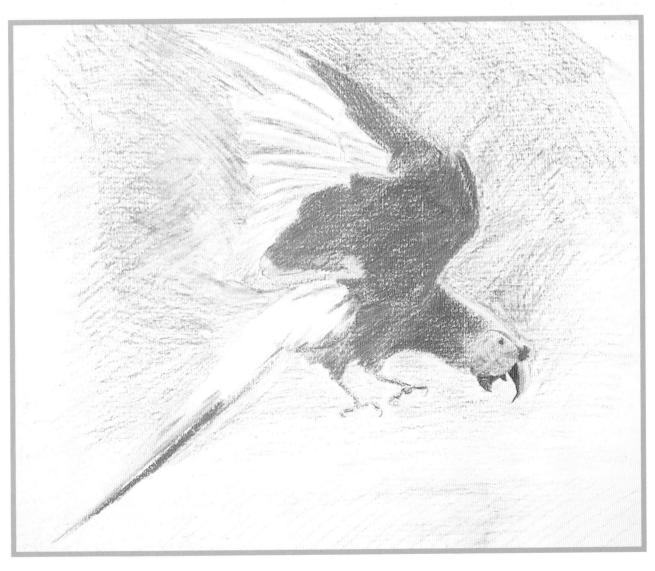

How can I draw fur realistically?

Often, people would like to draw their own pet—be it a dog, cat, or rabbit—but they are put off, thinking the fur will be much too difficult to attempt. Fur is made of fibers so thin that you cannot see them individually unless you are quite close. If you can see each hair, you may feel that you ought to draw them all, but this is the wrong approach. As with tackling a head of hair, it is best to squint your eyes and observe only the main areas of light and dark.

A sleeping animal, or one that stays still for a long time, is a good artist's model. With animals that seldom keep still, watch them for long periods of time and build up a drawing gradually from fleeting glimpses of the animal in the right position. An easy way out is to use a photograph that has captured just one of these fleeting moments. First, draw the outline, then look for the main dark areas. You may find this easier by squinting your eyes so that your vision is blurred. Block in the dark areas by simple hatching with a

Fur tends to hang in tufts so that one side of each tuft catches the light while the other side is in shadow. Look for the largest tufts and their shapes (perhaps by opening the eyes a little more), and draw them as dark patches.

Leave the lightest parts untouched except for any large tufts with strong shadow. Ignore any individual hairs you may see. Within the darker areas, add smaller tufts, keeping an eye on the main tonal contrasts as you work.

A dark background helps to bring out the paleness of the fur. Notice the large pale tufts of fur at the rear end protruding into the dark background. Where dark tufts protrude, such as from the underside, keep the background pale so that they are visible.

brown conté crayon.

Index

Page numbers in italic type refer	distance 37, 38	1 -
to illustrations.	aerial perspective 68, 68-9, 75, 91	image 8
	drapery	Ingres paper 119
A	folds 50, 52, 52–3	intensity 9
aerial perspective 8, 66, 68, 68-9, 70,	texture 54, <i>54</i> – <i>5</i>	interiors 97-113
75, 91	dusk 65, 89	figures in 97, 100, 100-3, 109-13,
animals 115, 142, 142		132–5
	E	lighting 97, 100, 101-5, 104,
В	easel, using 12	112–13
backgrounds 8, 43, 47, 58	electric lights 104, 104–5	Irises and freesias in a glass vase 60,
back lighting 43	ellipses 8, 11, <i>13</i> , 44, <i>44</i> , <i>62</i>	60-3
ballpoint pens 6, 22	enlarging 30, 30-1, 110, 138	
Baseball cap, bat, and glove 26, 26-9	erasers 7, 21	L
birds 136, <i>136–41</i>	eye level 78, <i>78</i>	Landscape with barn, fence, and road 36,
black 18, 28, 48	eyes 115, 125, <i>125–7</i>	36–9
blending 8		landscapes 36, 64-95
blocking in 8	F	figures in 78, 78-9
board, drawing 7	feathers 137, 138–9	proportion in 72, <i>72</i> –3
Boy on a staircase 110, 110-13	felt tip pens 6, 8	Leigh, Hilary 59
buildings 34-5, 65, 71, 74, 74-7	Figure looking out of a window 32, 132-5	lighting 13–14
in landscape 72, <i>72-3</i>	figures 115-35	artificial light 104, 104-5
burnishing 8, 14, 17, 22, 51, 58, 76, 80, 93	interior scenes 97, 100, 100–3,	color changes 61
	109–13, 132–5	interiors 97, 100, 100–5, 104,
C	in a landscape 78, <i>78</i> –9	112–13
cartoons 31	posing 116, <i>116–17</i>	nighttime scenes 65, 89, 89
chalk 6, 7	in snow 90, <i>91</i>	still life drawings 43, 43
Chamberlain, John 69	fires 56, 56, 106, 106–7	weather conditions 36, 43, 74-5
charcoal 7, 8, 20, 21	fixing and fixative 7, 8	linear perspective 9, 33, 33, 70, 76, 108,
Chinese white 7, 8, 14, 17, 22	flames 56, 56, 106, 106-7	132
clouds 80, 80-3, 92	floor tiles 99, 99	local color 9, 61
perspective 81	flowers 41, 57, 57-63	M and the second
Collicutt, Paul 83	focal point 8, 36, 135	M
color density 8	interiors 98, 98, 100, 110, 113	masking 113
colored grounds 8	landscapes 66, 66-7, 74, 77	measuring 11, 24, 24-5, 26, 48, 72
colored pencils 6, 7, 16-18, 16-18, 25,	folds 50, 52, 52-5	enlarging 30, 30-1, 110
26–9	foreground 8, 37, 66, 72, 72	human figure 118, 118-19
optical mixing 9, 16, 16–18, 76, 83, 93	foreshortening 8, 115, 117, 120, 120-1,	Melling, David 103
colored underdrawing 27	126–7	metal, polished 46, 46–7, 49–51
complementary colors 8	form 8, 13, <i>13–15</i> , <i>43</i> , <i>48–9</i> , 115	modeling 9, 13-15, 43, 48-9, 115
composition 8	Fruit in a copper pot 48, 48-51	monochrome 9
interiors 98, 98, 102	fur 142, <i>142</i>	mouths 115, 124, 124
landscapes 66, 66-7		movement 85, 88, 88
still life drawings 41, 42, 42, 62	G	
Constance, Diana 119	glass 45, 45, 63	N
conté crayons 6, 8	Graham, Neville 79	negative shapes 9, 32, 32, 37, 60
contours 8	graphite 6, 7, 8, <i>25</i>	nighttime scenes 65, 89, 89
copper 47, <i>49–51</i>		noses 115
correcting mistakes 21	H	nudes 115, 117, 119, 120-1
cross hatching 8, 16, 17-18, 20, 22, 83	hair 128, <i>128</i>	39.
two or more colors 93	hands 129, 129-31, 132, 134	0
	hatching 8, 13, 15, 18, 20, 44	ochres 9, 18
D	highlights 7, 8, 14, 27, 28, 44, 48–9, 75	optical mixing 9, 16, 16-18, 76, 83, 93
depth, creating 70, 70, 103	horizon 78, <i>78</i>	out of doors, drawing 36, 64-95
detail 71, 71	110112011 70, 70	out of doors, drawing oo, or so

Р	shiny surfaces 44-7, 112
painting 6, 16	sight size 9, 11, 24, 24–5, 26, 48, 60, 122
paper 6, 7	silk 54, 54–5
grain 23, 119	sketchbooks 6, 7
tinted 7, 8, 27, 46, 81, 89, 90, 106	skies 80, <i>80</i> – <i>3</i> , 82, 92, <i>93</i> – <i>5</i>
tooth 9	snow scenes 90
Parrot in flight 138, 138–9	slides, projecting 30
pastels 119	smoke 68
pencils 6-7, <i>43</i>	smudging 21, 49
grades 7	snow 90, 90–1
holding 12, <i>12</i>	stairs 97, 108, <i>108–13</i> , 109
sharpening 25, 45	still life drawings 41–63, 65, 97
pen and ink 6, 7, 20	stippling 9, 12, 21
people see figures; portraits perspective 8,	straight lines 35, 35
9, 33-4, 33-4, 50-1	Street scene, south of France 74, 74–7
aerial 8, 66, 68, 68–9, 70, 75, 91	sunlight 36, 43, 74–7, 82
clouds 81	interiors 97, 100, <i>100–3</i> , 110, <i>112–13</i>
figures 78, <i>78</i>	symmetrical objects 19, <i>19</i> , <i>62</i>
floor tiles 99, 99	5,
linear 9, 33, 33, 70, 76, 108, 132	Т
stairs 108–9	technical pen 9, 12, 21
photocopying 30	texture 9, 23, 25, 54, 54–5
photographs, working from 30, 30–1, 85,	tint 9
110, <i>110</i> , 136, 138	tone 9
picture plane 9	toning 9
pigment 9	Topley, Will 23
plumb line 9, 60, 120	Townend, John 73
portraits 115, 122, <i>122–8</i>	townscapes 65, 71, 74, 74–7, 86, 86–7
profile 132, <i>132–5</i>	trees 32, 32, 71, 71, 72
setting 41, 97	1.663 02, 32, 71, 77, 72
proportion 72, <i>72–3</i>	U
	underdrawing 9, 27, 48
R	undershading 9, <i>74</i>
rain 86, <i>86–7</i>	8 /
receding objects 34, 34, 36, 38, 70, 70	V
figures 78–9	vanishing point 9, 33, 50-1, 70, 76, 108-9
floor tiles 99, 99	velvet 54, <i>54–5</i>
reflections 44, 45, 45, 46, 46, 50	verticals
water 67, 84, 84–5	plumb line 9, 60, 120
wet surfaces 86, 86-7	vanishing point 33
ripples 84, 85	viewpoint 78, <i>78–9</i>
rule of thirds 9, 135	,
	W
S	water
scale 9	movement 85, 88, 88
scanner, using 30	reflections 67, 84, 84–5
scribbling 22	water-soluble pencils 59
seascapes 65, 84-5, 88, 92, 92-5	Waves breaking against rocks 92, 92-5
shading 9, 13, 13–15, 20, 20–3, 25, 43,	waves and surf 88, 88, 90, 92
103	weather conditions 36, 43, 65
shadows 13, 13-15, 25, 27, 43, 48	wet surfaces 86, 86–7
changing 43	white highlights 7, 14, 27, 28
clouds 80, 82	white objects 61
interiors 97, <i>102–3</i>	windows 111–13, 132–5
portraits 122–3	
snow 91	Υ
	yellow 18, 18, 60
	70